2008

Brenda-
Merry Christmas & Happy New Year!
Love-
Barb

IMAGES
of America

MIFFLIN COUNTY

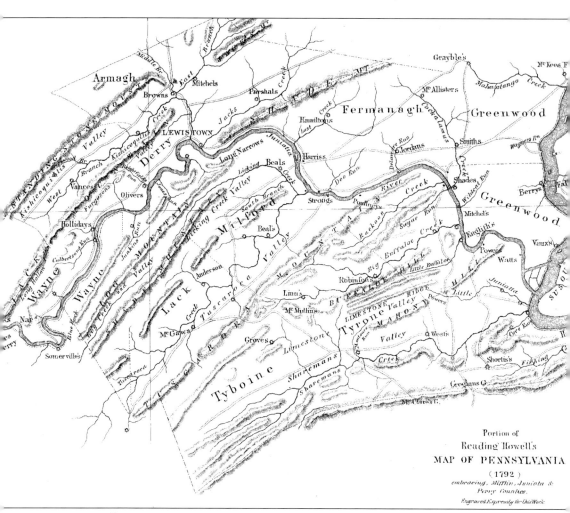

Portion of
Reading Howell's
MAP OF PENNSYLVANIA
(1792)
embracing, Mifflin, Juniata &
Perry Counties.
Engraved Expressly for this Work

In 1789, Mifflin was established as Pennsylvania's 21st county. This map, from the 1886 *History of the Susquehanna and Juniata Valleys*, shows Mifflin County three years after the original boundaries were formalized. In 1831, Juniata County was established out of Mifflin, which reduced the county to about half of its original size. (Courtesy Mifflin County Historical Society.)

On the cover: The back of this photograph is inscribed, "Farm Women Trip to New York City, 1949." The Rural Women's Association members from Mifflin, Juniata, and Huntingdon Counties await the bus at the Coleman Hotel on West Market Street in Lewistown. The local group went to Philadelphia in 1951, but also met regularly and even "roughed it" at a church camp during the summer months. (Author's collection.)

IMAGES
of America

MIFFLIN COUNTY

Forest K. Fisher

ARCADIA
PUBLISHING

Published by Arcadia Publishing
Charleston SC, Chicago IL, Portsmouth NH, San Francisco CA

Printed in the United States of America

Library of Congress Catalog Card Number: 2007929104

For all general information contact Arcadia Publishing at:
Telephone 843-853-2070
Fax 843-853-0044
E-mail sales@arcadiapublishing.com
For customer service and orders:
Toll-Free 1-888-313-2665

Visit us on the Internet at www.arcadiapublishing.com

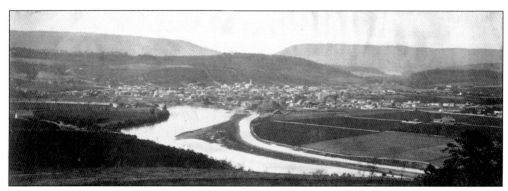

This 1870s panorama of Lewistown, looking north to the gap in Jack's Mountain, shows the Pennsylvania Canal and the Juniata River at the county seat. Canal traffic included both passengers and freight, which made Lewistown a center of commerce in the mid-1800s. Despite disease and construction delays caused by high water or floods, the canal opened to Lewistown in 1829. (Courtesy Mifflin County Historical Society.)

CONTENTS

Acknowledgments 6

Introduction 7

1. Mifflin County Genesis 9

2. Judge William Lewis's Town 25

3. Around the County 69

4. Pleasant Diversions 93

5. Tragic Events 109

6. Noteworthy Individuals 117

Bibliography 126

Index 127

ACKNOWLEDGMENTS

The motto of the Mifflin County Historical Society, "Preserving the Past for the Future," was the guiding principle behind this project. This book offers a glimpse of our county's interesting, colorful past, and to the extent possible, preserves it for another generation. The historical society's extensive collection was open to me during this project. To say collection is a misnomer, since it is really multiple collections of historical papers, microfilm, and photographs. These mementos of Mifflin County's past represent decades of volunteer work, preserving and conserving local treasures. I would like to thank the Mifflin County Historical Society's board of directors for allowing me access to this vast resource.

In addition to the society's resources, I was able to access the photograph and negative collection of the Kepler Studio of Lewistown, which was operated by my grandfather Luther F. Kepler Sr. (1902–1969) and his brother James A. (1906–1990) from 1924 through 1984.

Then there are individuals who shared their real-photo postcards and vintage photographs for the project. Rather than allowing images to remain closed away, these collectors shared them. The photographs and real-photo postcards are unique views—snapshots in time—many never before published. A special thanks is extended to Robert L. Aumiller, Ronald Aurand, James R. Fosselman, and Mifflin County Historical Society board member Ernest Solt for sharing a portion of their private collections. Thanks also to author Mark L. Gardner for his photograph of Richard Smith Elliott.

I would also like to thank historical society past president and board member Daniel M. McClenahen for generously sharing his wealth of knowledge on Mifflin County and United States history. Thanks also to the historical society's research librarian, Jean Laughlin, who aided me with invaluable and comprehensive information from the historical society's vast archives, which were well organized and coherently presented. A special thank-you to Karen Aurand, historical society executive secretary, who helped with research and checking the accuracy of historical facts.

INTRODUCTION

Mifflin County, located in the Ridge and Valley Appalachians region of central Pennsylvania, was developed along branches of the Juniata River system. Kishacoquillas Creek empties into the Juniata River at Lewistown, where the Shawnee village of Ohesson existed for generations during the 17th and 18th centuries. Traders James LeTort and Jonah Davenport were the first to describe Ohesson in 1731.

Ohesson's principal chief, the Shawnee Kishacoquillas, and other American Indian leaders attended a 1739 conference in Philadelphia, according to Colonial records. Local tradition recounts that Kishacoquillas was a friendly acquaintance of a Scots-Irishman named Arthur Buchanan, first European settler in Mifflin County. In 1749, Lewis Evans's map of the area shows a village at the mouth of Kishacoquillas Creek, which he names Kishequochkeles, a Shawnee word for "the snakes are already in their dens."

In 1754, the heirs of William Penn bought a large tract of central Pennsylvania from the Six Nations of the Iroquois, including what became Mifflin County. Known as the Albany Purchase, this opening permitted European settlement. By the late summer of that year, Buchanan set out from Carlisle toward this newly opened land, following the Juniata River, eventually coming to the mouth of Kishacoquillas Creek and the village of Ohesson. He was in a valley 28 miles long and averaging 6 miles wide. On the south side of the valley were the Blue Mountains, breached where Buchanan crossed through Granville Gap. To the northwest was Jack's Mountain, where Kishacoquillas Creek made the only gap there for 20 miles. Eastward through these parallel ranges was the Juniata River, which pressed so close to its banks that it made travel impossible. Called the "Long Narrows" in earlier times, this stretch is now referred to as the Lewistown Narrows.

Buchanan had found an ideal trading location. It was the only practical spot where the north-south and east-west routes through the mountainous region intersected. It was here that he set up his trading post. Buchanan's wife, Dorcas Holt Buchanan, was the kind of person who possessed a pioneer spirit, so typical of those early settlers. Her spirit brought her to this part of the Pennsylvania colony, and her life here deserves further explanation.

Dorcas was born in Ireland around 1711 where she met and fell in love with Henry Holt. Holt's parents greatly disapproved of the lower-class woman. In a plot right out of the movies, Holt's family had her kidnapped and stowed aboard a ship bound for America. Holt's love was strong, so he followed her shortly after and found her in Philadelphia where they were married. The couple eventually settled in the bustling frontier town of Carlisle. Holt was a silversmith by trade and made a fair living for his wife and growing family. As the traditional story goes, he was called back to Ireland, but was never heard from again. Accounts vary, but one notes his

ship was lost during its crossing of the Atlantic Ocean, and another has him killed en route to Philadelphia prior to his voyage. Regardless, historically his fate is unknown.

Considering this was the 18th century, Dorcas persevered, raising her two fatherless sons for three years before meeting and marrying the American Indian trader Buchanan. He had grand ideas of making a fortune in the trade. They made the arduous journey westward from Carlisle over narrow paths with little food, eventually settling near Ohesson. The Buchanans built a cabin, establishing their trading post across from the American Indian village. Dorcas became the first European woman in the area. During the French and Indian War around 1756, the family moved back to Carlisle for safety reasons because they had children of their own. However, Buchanan died in 1760. Then Dorcas made a startling decision for the era—to return to operate the trading post alone. She registered her husband's land in 1762 with the Pennsylvania authorities and, as the decades passed, she became a businesswoman, buying and selling land from which Mifflin County and Lewistown would be created.

Dorcas lived an adventurous life, as did many settlers of the era. At some point, perhaps while in her 50s, she lost her sight, only to regain it years later. A description of her states she was, "a high spirited, determined woman, full of energy and fire and possessed of a nature easily aroused." She died in 1804 at the age of 93. Her grave is in the Old Town Cemetery, Mifflin County's first community burial ground, at Water and Brown Streets in Lewistown. Buchanan Elementary School and Dorcas Street, also in Lewistown, are memorials to the Buchanan family.

Mifflin County's seat of government, Lewistown, named for a member of the Pennsylvania legislature, was a hub of commerce, with rail lines, stagecoach lines, a canal, and a turnpike converging here. Lewistown's center is now called Monument Square. A memorial was constructed at the center of town in 1906 and was originally dedicated to the soldiers and sailors of the Civil War. It was rededicated in 1969 to all residents of Mifflin County who served and died in service of the country. The memorial is guarded by four vintage cannons from the Civil War era.

Within one square mile of this central location, an impressive list of people and events that influenced a broad cross section of American history can be found. A partial list of prominent individuals who were born or who lived or worked in the Lewistown area includes notable American Indian leaders of the Colonial period; six United States generals; three defenders of the Alamo; the builder of the United States fleet of the War of 1812; a United States naval commodore who led a fleet in the Mexican War; the man who led the first soldiers to fight for the Union in the Civil War; 19 newspaper publishers; four Congressional Medal of Honor recipients; the first American naval officer to die in submarine duty during World War I; the women who started the school system in Panama; the wife of Pres. Abraham Lincoln's secretary of the navy, Gideon Welles; the parents of Robert Frost; composer Stephen Foster's wife; one of the four World War II chaplains, George L. Fox, who died on the torpedoed troopship *Dorchester* and is immortalized on a U. S. postage stamp; the longtime voice of Pennsylvania State University football, Fran Fisher, and actor Joe Campanella, both of whom worked at local radio stations.

In addition, a battle of the French and Indian War was fought within that same square mile. The only stone to ever be removed from Lincoln's tomb in Springfield, Illinois, is here, too. A 1776 copy of the Declaration of Independence was kept in a box just a couple of blocks up Main Street from the courthouse. And a local health drink with a secret recipe, which drew the famous from Hollywood prior to World War II, was concocted a block away.

Considering this list of historical connections, it is safe to say that Mifflin County has a unique and colorful history, and it all started centuries ago along the Juniata River.

One

MIFFLIN COUNTY
GENESIS

The Juniata River is the county's eastern entrance, flowing through a narrow valley among the folds of the Allegheny Mountains. A historical marker placed nearby in 1947 reads, "Travel History. Five stages of travel can be recalled here. Concrete covers the old turnpike. Opposite are the ruins of the old canal. The Juniata was once filled with river craft. Across the river is the Pennsylvania Railroad." (Author's collection.)

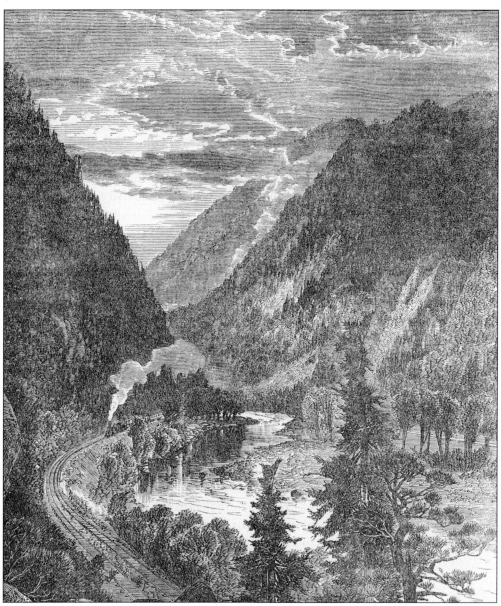

This 1870s image depicts the narrows, a natural feature once referred to as the Long Narrows and later as the Lewistown Narrows. Archaeological evidence points to American Indian habitation in this area parallel to the Juniata River as long as 9,000 years ago, while the earliest pioneer traders entered this part of the Pennsylvania frontier along American Indian trails around 1730. T. Addison Richards described the location in an 1856 travelogue appearing in *Harper's New Monthly Magazine*, writing, "In the very heart of that wild portion of Pennsylvania is the unvisited and almost unknown home of the Juniata, one of the loveliest of the rivers of America, and, with the neighboring waters of the Susquehanna, of which it is the principal affluent, most justly the pride of the Keystone State. The Juniata, leaping from the crags and chasms of the Alleghenies, winds its lonely and devious way eastward through a hundred and fifty miles of mountain solitude to its final nuptials with the Susquehanna." (Courtesy Mifflin County Historical Society.)

Mifflin County opened to settlement as natural obstacles were overcome. Animal trails expanded into American Indian paths, turnpikes evolved from wagon roads, and finally concrete highways replaced them all. U.S. Route 322 followed the Harrisburg to Pittsburgh turnpike, shown above in 1915. The journal of Rev. Charles Beatty describes the entrance to Mifflin County. His diary's August 26, 1768, entry states, "We traveled the Juniata River eight miles to a place called the Narrows, where rocky mountains bound so close upon the river as to leave only a small path . . . at this time [the waterway] is greatly encumbered by trees fallen across it, blown by a great wind . . . we were obliged to walk . . . along the edge of the water." The improved roadway in the 1930s, shown below, followed the route of the turnpike and Pennsylvania Canal. (Author's collection.)

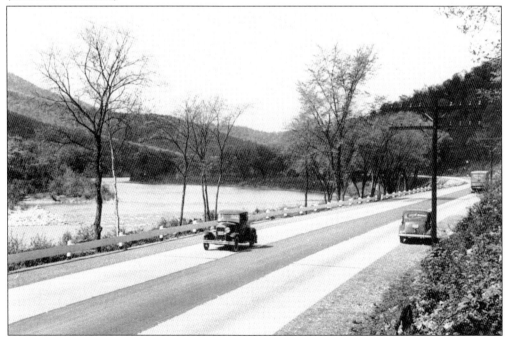

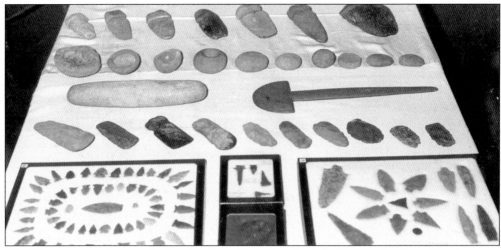

The Shawnee people were the last in a long line of earlier inhabitants. Artifacts like these are routinely found locally during road construction or through agricultural activity. Following an extensive flood in 1972, large numbers of stone artifacts were revealed along the Juniata River. Shown here are stone projectile points, axes, knives, and other tools, as well as paint pots, in a historical society display. (Courtesy Mifflin County Historical Society.)

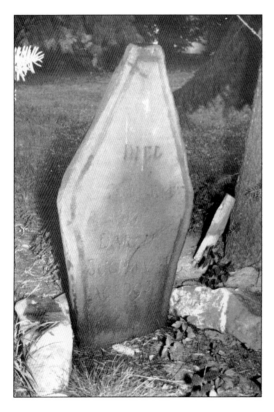

Dorcas Holt Buchanan (1711–1804) was the first European woman to settle in what would become Mifflin County. Her grave marker, in the Old Town Cemetery, was carved from native stone. She operated a trading post and tavern near where Kishacoquillas Creek joins the Juniata River with her husband Arthur Buchanan. Widowed twice, Dorcas owned land that would become Lewistown. (Courtesy Mifflin County Historical Society.)

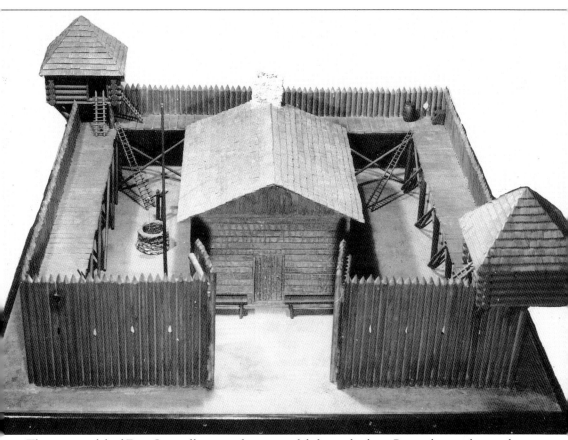

This is a model of Fort Granville, one of a series of defenses built in Pennsylvania during the French and Indian War. The fort was located along the Juniata River about one mile upstream from where Lewistown would be founded. The fort was captured in 1756 by a force of Delaware Indians and French. Those inside were killed, wounded, or captured. Lewistown High School vocational students constructed this model in 1941 from materials provided by the Mifflin County Historical Society. Plans were drawn up by Lewistown High School Vocational Department drafting students, based on research provided by Dr. Sylvester K. Stevens of the Pennsylvania Historical and Museum Commission and professional archaeologist Eugene M. Gardener of New York. Supervising the project was instructor John W. Brassington. Students working on the construction were Abram Henry, Charles Brindel, Fred Orme, Harry Miller, Charles Miller, Lloyd Weston, Fred Myers, Richard Hackenberry, Fenton Aurand, John Durst, Lyman Guss, John Goodwin, Eugene Speece, William Cooney, Harry Rietze, David Aumiller, Robert Sheets, David Earnest, Jack Moyle, Harry Botteicher, Merrill Bailey, and Rex Bailey. (Courtesy Mifflin County Historical Society.)

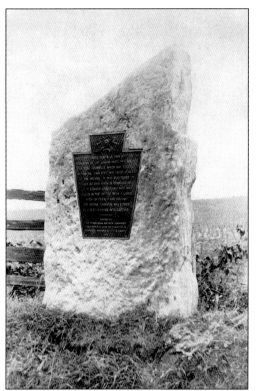

This stone and bronze marker was the first official memorial of any kind in Mifflin County. The bronze, keystone-shaped plaque affixed to the stone base states, in part, "About 650 yards south of this spot, on the high bank of the Juniata River, was the site of Fort Granville, which was erected in 1755-56 . . . was destroyed on July 30, 1756 . . . Erected by the Pennsylvania Historical Commission in co-operation with the Committee of Historical Research of Mifflin County, 1916." This bronze marker was moved in 1941 and given a concrete base. Six years later, a new historical marker was placed nearby at the Pennsylvania Department of Highways building, located at West Fourth Street in Lewistown. Shown here, from left to right, are J. Martin Stroup (Mifflin County Historical Society secretary), Ray Cunningham (Mifflin County superintendent of highways), and Guy Croyle (Pennsylvania Department of Highways). (Courtesy Mifflin County Historical Society.)

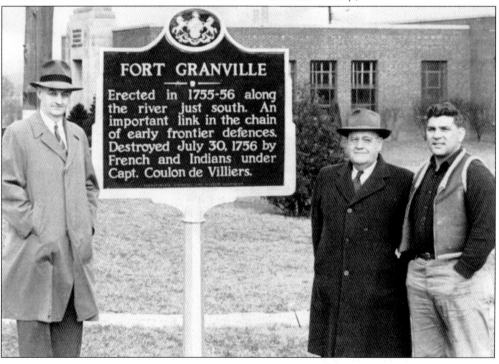

A bicentennial pageant titled "From These Ashes There Shall Rise" was presented in 1956 to commemorate the destruction of Fort Granville and chronicle the early American Indian inhabitants and their encounters with the first settlers. Hundreds joined to become cast members, sing in the chorus, build sets, make costumes, and give technical assistance. Elizabeth Steele, a Lewistown High School English teacher, wrote and directed the pageant. (Courtesy Mifflin County Historical Society.)

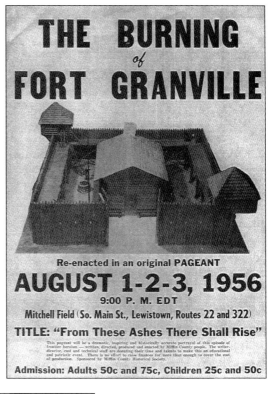

THE BURNING *of* **FORT GRANVILLE**

Re-enacted in an original PAGEANT

AUGUST 1-2-3, 1956

9:00 P. M. EDT

Mitchell Field (So. Main St., Lewistown, Routes 22 and 322)

TITLE: "From These Ashes There Shall Rise"

This pageant will be a dramatic, inspiring and historically accurate portrayal of this episode of frontier heroism — written, directed, produced and enacted by Mifflin County people. The writer-director, cast and technical staff are donating their time and talents to make this an educational and patriotic event. There is no effort to raise finances for more than enough to cover the cost of production. Sponsored by Mifflin County Historical Society.

Admission: Adults 50c and 75c, Children 25c and 50c

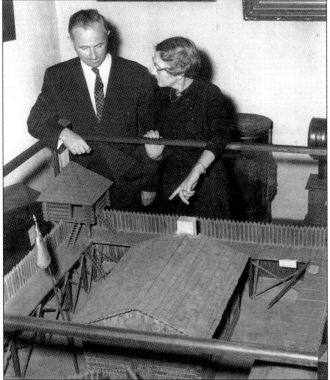

Steele and Dr. Sylvester K. Stevens (left) of the Pennsylvania Historical and Museum Commission are shown in 1956 with the Fort Granville model at the Mifflin County Historical Society's museum, which was located, at the time, in the basement of the municipal building in Lewistown. (Courtesy Mifflin County Historical Society.)

15

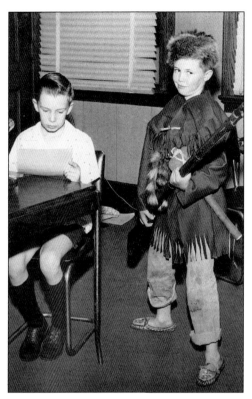

Clyde Rupert (left) and Lewis Headings Jr. are shown rehearsing for the Fort Granville bicentennial pageant "From These Ashes There Shall Rise," which was held at Lewistown's Mitchell Field in August 1956. Headings played the role of Simon Girty Jr., who was in the fort at the time of its capture during the French and Indian War on August 1, 1756. Rupert is reading the scene's dialogue. (Courtesy Mifflin County Historical Society.)

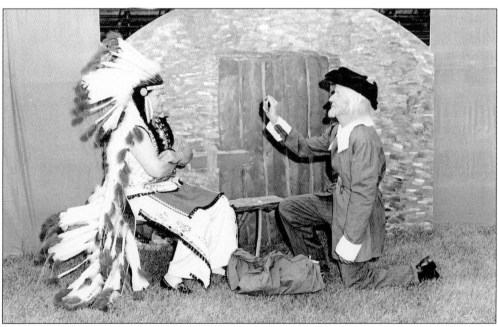

One tableau during the pageant represented the return of the settlers to the Juniata Valley. "And Arthur Buchanan came in friendly gesture to trade with the Ohessons." James Kinney (left) represents the local American Indians, while V. H. Butterworth portrays Arthur Buchanan. (Courtesy Mifflin County Historical Society.)

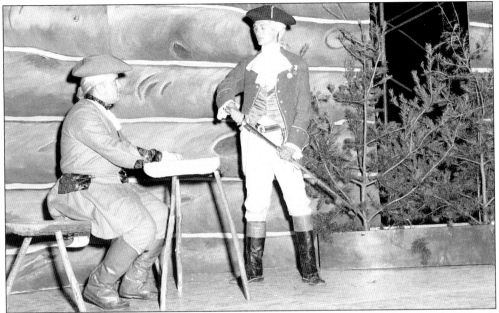

Before the burning of Fort Granville by the French and American Indians, the French commander gave the fort an opportunity to surrender. "And so we come to August 1, 1756—a day of fate for those left at Fort Granville!" Ray C. Allison (left) portrays the commander of the fort, Capt. Edward Ward, and Ronald Zimmerman appears as the French commander. (Courtesy Mifflin County Historical Society.)

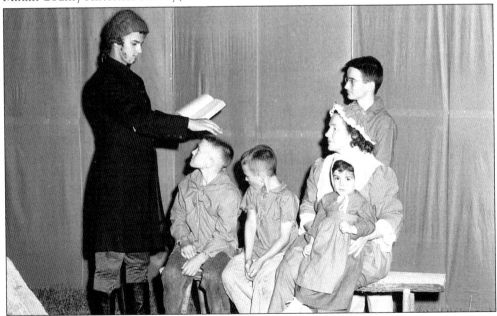

Another tableau recounted the return of the settlers and the first church service. "And the undaunted settlers returned to take up their land warrants. They began anew; and they brought with them religion . . . a deeper faith in an Omnipotent God!" Pictured here, from left to right, are Charles Drozda, Thomas Day, Patrick Day, Phyllis Day (wife of Hugh T.), Philip Day (on Phyllis's lap), and Alex Day (standing). (Courtesy Mifflin County Historical Society.)

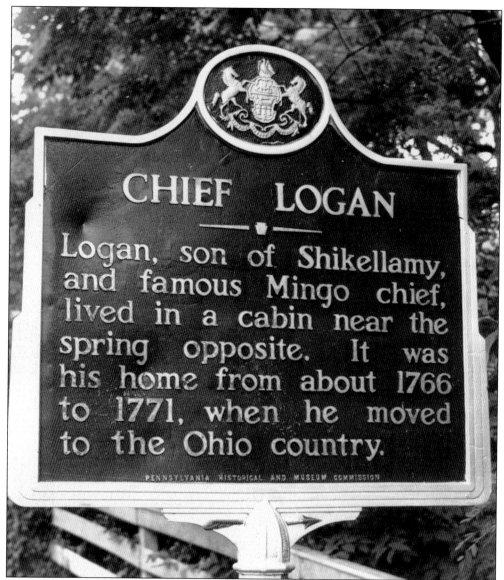

CHIEF LOGAN

Logan, son of Shikellamy, and famous Mingo chief, lived in a cabin near the spring opposite. It was his home from about 1766 to 1771, when he moved to the Ohio country.

PENNSYLVANIA HISTORICAL AND MUSEUM COMMISSION

One of Mifflin County's notable American Indian inhabitants from Colonial times was Logan, who was often referred to as a Mingo chief. This 1947 Pennsylvania historical marker notes that Logan's cabin was located just north of Reedsville along old U.S. Route 322 in Mifflin County's Brown Township. Logan came upon the national stage through the writings of Thomas Jefferson, who admired Logan's eloquent reaction to his tragic life, which was symbolic in many ways of the fate of all American Indians facing European encroachment and settlement. Logan's famous speech, known as "Logan's Lament," detailed his friendship with the settlers and described the cruel treatment given to his people by these same settlers. The speech became a literary icon of the time and was reprinted in the popular 19th-century *McGuffey Reader*. Logan's words were memorized by generations of schoolchildren. (Courtesy Mifflin County Historical Society.)

Born a century prior to photography, Logan's appearance comes from personal descriptions in diaries and letters or oral recollections. There is no life portrait or painting of Logan. "Logan was the finest specimen of humanity," is how this often-repeated description of him begins, spoken by one who knew Logan personally, William Brown, who was an early settler and Mifflin County's first judge. The image is from the 1850s. (Courtesy Mifflin County Historical Society.)

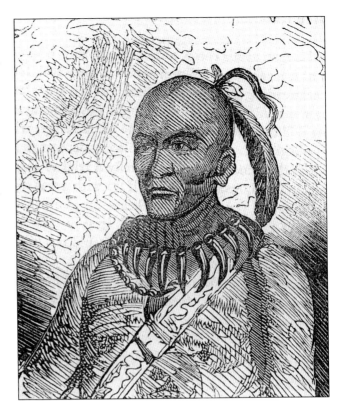

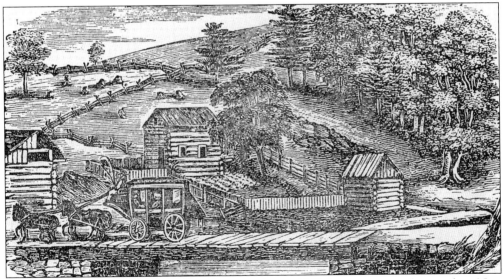

This engraving depicts Logan's Mifflin County cabin in 1842. Logan came to the area from New York but went to the Ohio Territory in 1771, joining hostilities against the English following the massacre of his family by European settlers. Tradition says his famous speech was read at the peace conference when hostilities ended. Logan was murdered in Ohio around 1780. (Courtesy Mifflin County Historical Society.)

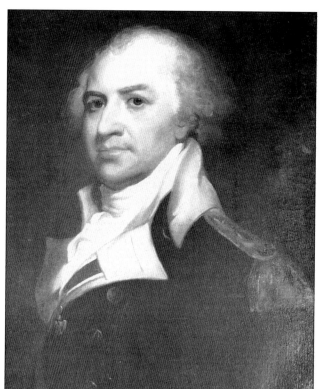

Mifflin County's namesake, Thomas Mifflin (1744–1800), was a popular Pennsylvania politician and soldier from Philadelphia. He was a general in the Continental army during the American Revolution, a member of the provincial assembly, and a delegate to the Constitutional Convention of 1787. He served as speaker of the Pennsylvania House of Representatives and was the first governor of Pennsylvania. (Courtesy Pennsylvania Historical and Museum Commission.)

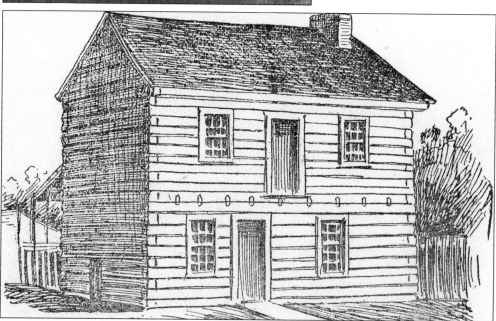

This early sketch shows the first courthouse, a two-story log building that was a combination jail and courtroom constructed in 1790 on the northwest corner of South Wayne and West Market Streets. The site was the focal point of the Lewistown riot in 1791. Though peacefully resolved, the confrontation resulted from a dispute over the seating of the county's first judge. (Courtesy Mifflin County Historical Society.)

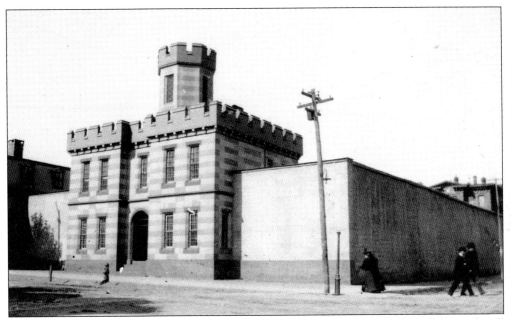

This is the Mifflin County Jail in 1900, where the first courthouse was located. Records tell that the original log building was too small from the start. A later stone structure served as a jail after the courthouse was moved to the town square. In 1856, this jail was constructed and remained until 2002, when the new Mifflin County Correctional Facility was built on the site. (Author's collection.)

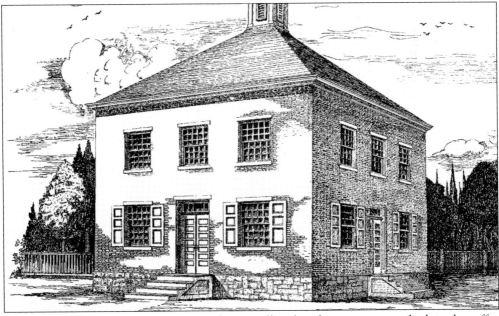

Mifflin County's second courthouse is architecturally referred to as a structure built in the coffee mill style. The two-story, square courthouse had a cupola with doors opening from two sides, one on South Main Street and the other on East Market Street. The second courthouse served as a community hall. Church services, public meetings, and the county's first murder trial occurred within its walls. (Courtesy Mifflin County Historical Society.)

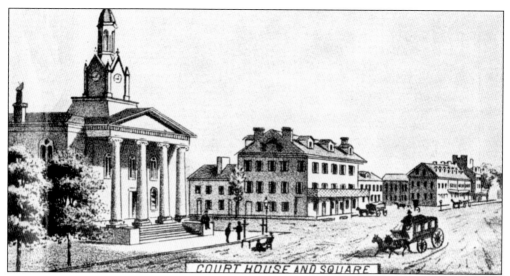

The second courthouse occupied the area in front of the 1843 building shown in this old print. The Lewistown newspaper *Cut Sharp* editorialized in 1841 about the condition of the second courthouse and the modern convenience that recently came to town—public water. The old building was an eyesore, blocking the view, in the *Cut Sharp*'s opinion, of the new buildings on Market Street. (Courtesy Mifflin County Historical Society.)

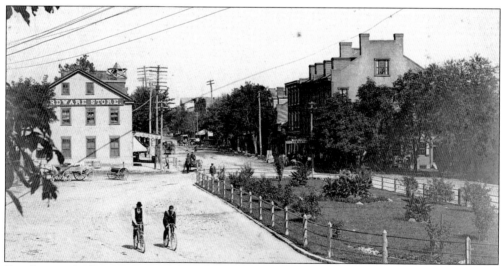

Bicyclists circle the town square prior to 1906. Referred to as the "diamond" in old articles and accounts, this was the location of the county's second courthouse prior to construction of the third hall of justice in 1843. Local boys played football, farmers sold their produce, people picnicked, and meetings were held at this location. (Courtesy Mifflin County Historical Society.)

This is Mifflin County's third courthouse as it looked in the 1860s. The final cost of the building in December 1843 was almost $15,000. On October 26, 1843, the McVeytown newspaper *Village Herald* critiqued, "We suppose that there is not one (courthouse) in our whole Commonwealth that excels it, but there are scores of them that sink into insignificance when compared with it." (Courtesy Mifflin County Historical Society.)

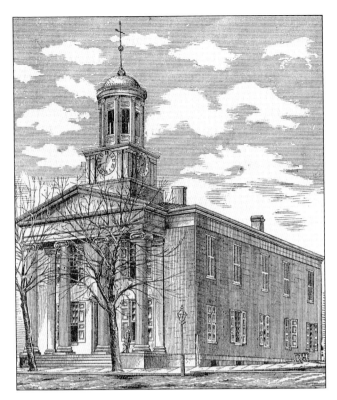

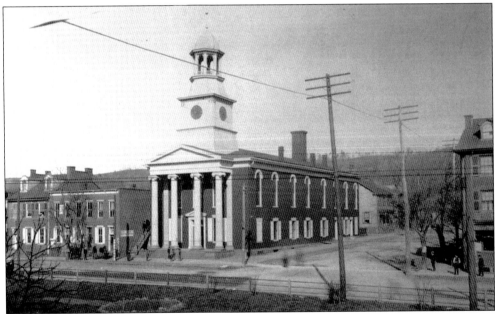

The third courthouse in this pre-1906 photograph shows the alterations made when the roof was lifted four feet during an 1878–1879 renovation. Each column was raised, and semicircular details were added to the tops of second-floor windows. The building was also extended up North Main Street. These elements can still be seen today, as can the changes made to the clock tower. (Courtesy Mifflin County Historical Society.)

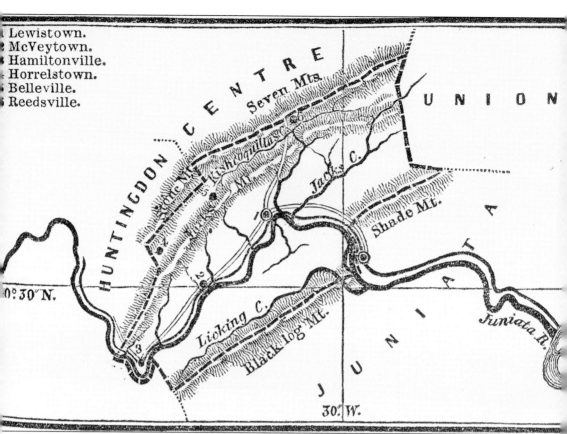

1 Lewistown.
2 McVeytown.
3 Hamiltonville.
4 Horrelstown.
5 Belleville.
6 Reedsville.

This 1846 map shows a number of communities and the county's borders that have remained since 1834. On the northwest, the county is bounded by Centre County; on the north and east by Union and Snyder Counties; on the southeast by Juniata County; and on the south and west by Huntingdon County. Its length is about 30 miles, and its width is about 15 miles. The area is about 360 square miles or 230,400 acres. The oldest part of the county boundary is the Juniata River, forming the Huntingdon County line when Bedford was formed in 1771. The western part of the Kishacoquillas Valley was in Cumberland County until it was transferred to Bedford in 1779, but then returned in 1789. One of the greatest arguments prior to Mifflin County's founding was the designation of the county seat, a debate that was settled in 1789 by an act of the Pennsylvania assembly that established Mifflin County. (Courtesy Mifflin County Historical Society.)

Two

Judge William Lewis's Town

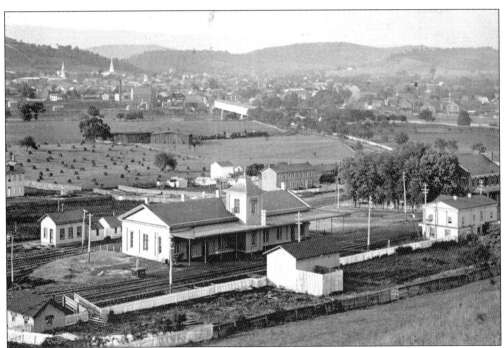

This is Lewistown as it looked prior to 1874. The view of the county seat is to the north, and the Pennsylvania Railroad station at Lewistown Junction is in the foreground. A covered bridge, visible above the railroad station, dates the image. This bridge spanned the Juniata River but was destroyed during a tornado in 1874. Lewistown was selected as the county seat over rival Mifflintown, located south of the Long Narrows. That town became the county seat of Juniata County in 1831. (Courtesy Mifflin County Historical Society.)

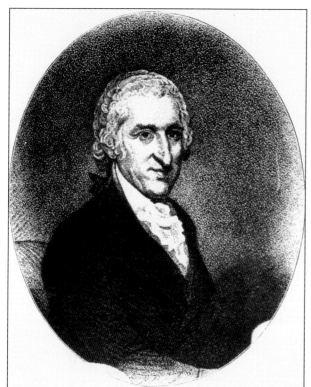

Lewistown was named for William Lewis (1752–1819), a Philadelphia Quaker, lawyer, legislator, and federal judge. He actively advocated for the gradual abolition of slavery in Pennsylvania. Lewis was a member of the Pennsylvania assembly when the county was established and was instrumental in placing the county seat at the location where Kishacoquillas Creek enters the Juniata River. (Courtesy Pennsylvania Historical and Museum Commission.)

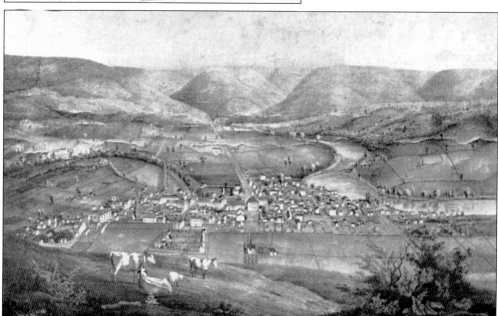

An act of the Pennsylvania assembly incorporated Lewistown as a borough on April 11, 1795. The town contained about 120 dwellings, plus the original log combination courthouse and jail. The second courthouse, seen in this image in the town square, was built in 1798. The panorama, looking southeast from Ard's Ridge, earlier called Ard's Hill, was a popular engraving of Lewistown in 1841. (Courtesy Mifflin County Historical Society.)

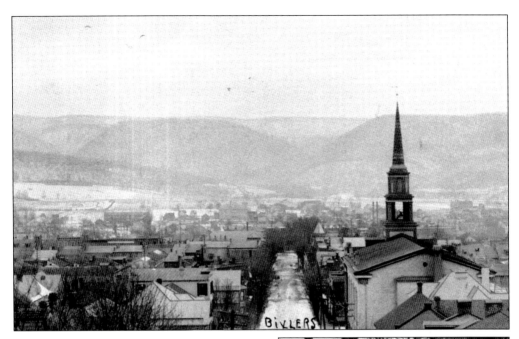

Bixler Gap is shown in this panorama of Lewistown looking down Brown Street toward the western end of Long Narrows. The location has an eerie story attached to it, sometimes titled "The Witchy Woman of Bixler Gap." The account tells of the healing powers of one Mrs. Bixler, a member of a pioneer family and the gap's namesake. For a price that was not always monetary, as the story goes, she would prepare cures for the locals. In the days before trained physicians, folk medicine sufficed to aid the sick and injured or even the lovelorn. Bixler fell into the category of a healer. The traditional story tells of her less benevolent practices, too, when she would appear as a cat to cast spells on enemies. (Above, courtesy Ernest Solt; right, courtesy James R. Fosselman.)

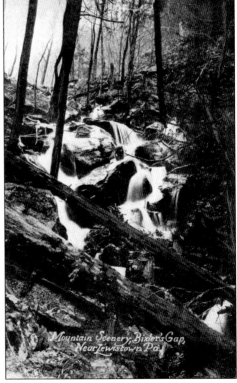

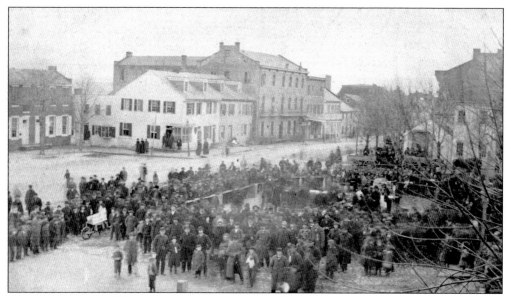

A crowd in the late 1800s is shown in front of the 1843 courthouse, just out of view to the right. The buildings or businesses on the south side of West Market Street, from left to right, are an insurance office, George W. Elder's law office, Fetterolf's, George Rarick's store, Dr. Myers' office, Harry Jackson (building owner), Coleman Hotel, Nolte's Restaurant, Dr. Moses Thompson's dental office, and Espby Bakery. (Courtesy Mifflin County Historical Society.)

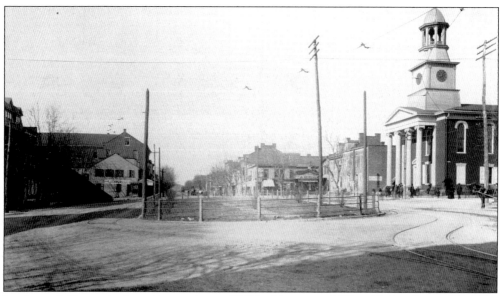

Lewistown's Square is shown here prior to 1906 looking toward West Market Street. Note the trolley tracks on each side of the oval. A town beautification movement improved this central section of the town by adding plantings and a fence. Eventually a monument honoring Civil War soldiers and sailors was erected here. (Courtesy Mifflin County Historical Society.)

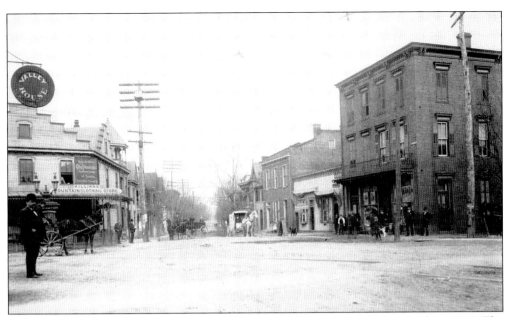

A bustle of activity is shown on the streets of Lewistown in this photograph from about 1900. The view, known as Fountain Square or Five Points, is looking east to Chestnut Street. The low white building on the right is the Ulrich bakery. A sign out front advertises Dutch cigars. The fountain is shown behind a horse and wagon to the left. (Courtesy Mifflin County Historical Society.)

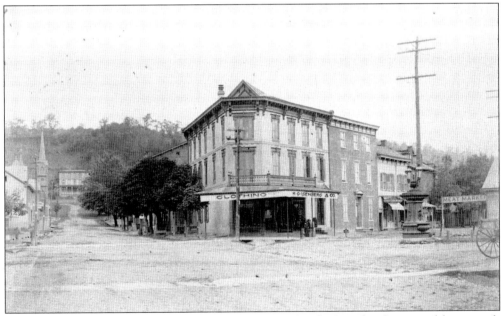

The fountain, at right, was constructed in the 1890s for the benefit of man and beast, with low troughs on either side for the convenience of horses. The fountain was dismantled prior to World War I. North Dorcas Street is to the left, with Valley Street to the right. The steeple of the Catholic church building can be seen up North Dorcas Street. (Courtesy Mifflin County Historical Society.)

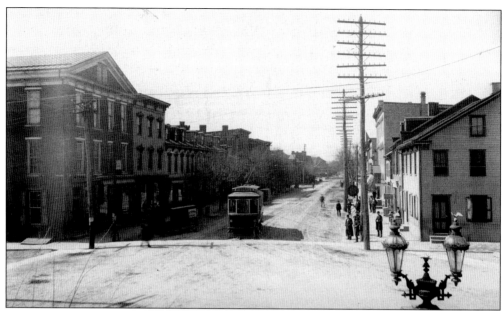

The Lewistown and Reedsville Electric Railway Company began trolley service in 1900, running cars from the Juniata River to Burnham. A car and tracks are visible in this photograph that looks west on East Market Street. The International Order of Odd Fellows building, to the left at the corner of South Dorcas and East Market Streets, was later the site of Danks and Company department store. (Courtesy Mifflin County Historical Society.)

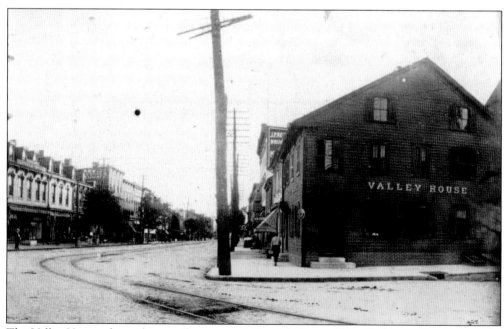

The Valley House, shown here at the corner of East Market and North Dorcas Streets, was the oldest hotel in Lewistown in 1911. Samuel Sloan opened the establishment in 1800, calling it the Black Bear. The hotel was 111 years old when it closed for business in April 1911 and was converted to a clothing store. (Courtesy Ernest Solt.)

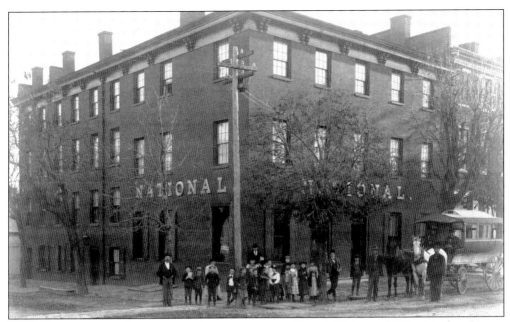

James Turner operated an inn at the west corner of South Main and West Market Streets around 1845. The establishment later became known as the National, shown here around 1895, under proprietor James H. Clover. Rates were $2 per day. Note the horse-drawn omnibus that transported passengers to and from the railroad station. At the time it was razed, the hotel was known as the Taft. (Courtesy Mifflin County Historical Society.)

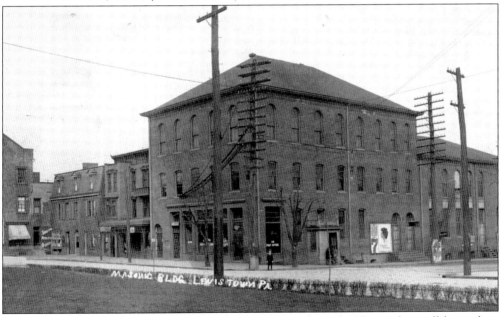

The Masonic temple building, across South Main Street from the National, is still located on the square at the east corner of South Main and East Market Streets. The local Masonic lodge occupied the upper floors, while the post office and the Temple Theatre were at street level. The cornerstone for the building was laid in 1893, and construction was completed the next year. (Courtesy Ernest Solt.)

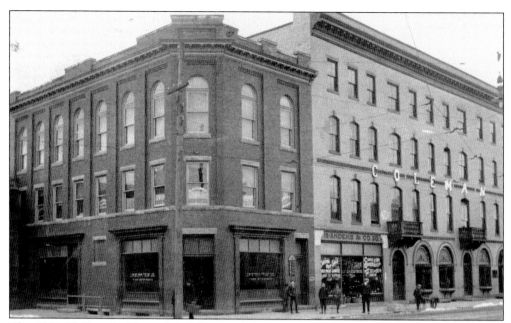

The 1906 Wollner building, shown here at left around the time of World War I, is a locally significant, early-20th-century, commercial, three-story brick structure at 16 West Market Street. Its significance lies in its architecture and its association with Calvin Greene, a prominent local businessman and founder of the Lewistown Trust Company. The Coleman Hotel stands just to its west. (Courtesy Ernest Solt.)

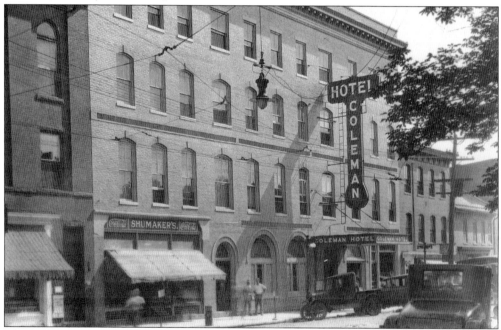

The first building to occupy the Coleman Hotel site was the log home and office of Dr. Henry Buck before 1794. Later the Red Lion Inn operated there during the canal days of the 1830s and was a stopover for travelers on the Pennsylvania Railroad after 1849. The building was rebuilt after fires in 1871 and 1892. This photograph dates from the 1920s. (Author's collection.)

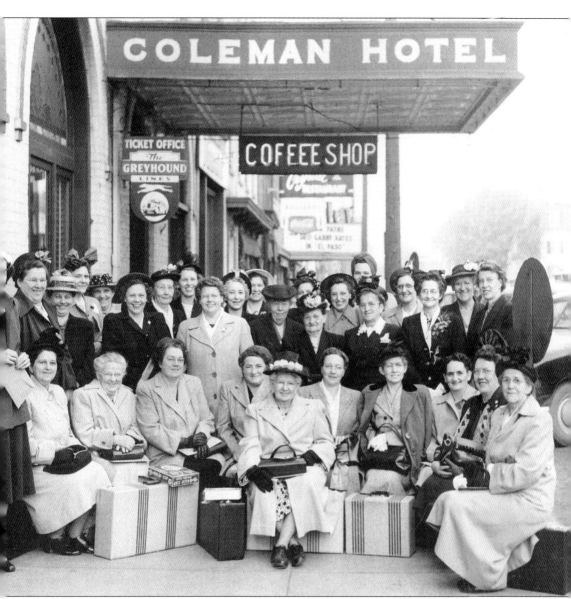

The Rural Women's Association members await the tour bus to take them on an excursion to New York City in 1949. The Greyhound bus stopped at the Coleman Hotel for this trip; however, the group met regularly and camped during the summer months. The Mifflin County Historical Society helped identify many, but not all pictured. The ladies that have been identified include, from left to right, (first row) Violet Dunmire (standing), Louise Beatrice Vogt, Grace Aurand (wife of Ira), Sarah Grace Aurand (wife of Fern), Mertie Aurand (wife of Alvin), Iva Bradford (wife of William), Sidney Aurand (wife of George), Ethel Kinsel (wife of Eugene), Emily Fisher, unidentified, unidentified, Julia Rhodes (wife of Allen); (second row) Esther Aurand (wife of Maurice), Agatha Huffnagle (wife of Wilson), Alverna Mitchell (wife of Samuel), Anna Rupert (wife of Fern), Dorothy Bell (Clarence), Millie Snyder (wife of Charles), unidentified, unidentified, unidentified, unidentified, Anna C. Reed, unidentified, Verna Laughlin (wife of John), unidentified, unidentified, Mabel Bradford (wife of Herbert), unidentified, Beulah Ruble (wife of Lawrence), and Mrs. Cloyd Zeigler. (Author's collection.)

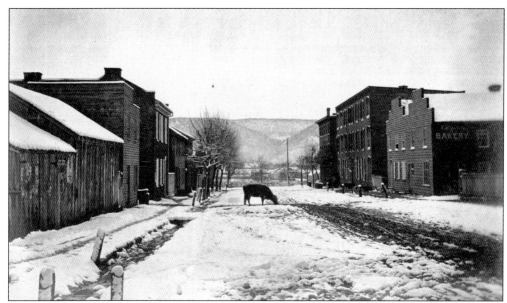

May 1, 1872, saw an early spring snowstorm leave a coating of snow across the area, as this photograph of South Dorcas Street depicts. It appears to have also brought out the stray cow seen grazing in the street. The last structure on the right is the Davis House. None of the buildings shown are now standing. (Courtesy Mifflin County Historical Society.)

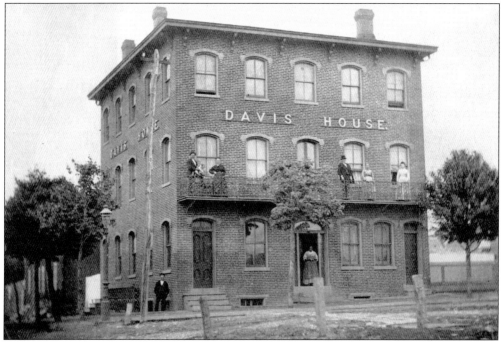

The Davis House, located on South Dorcas Street, was one of Lewistown's numerous hotels. The turnpike brought stagecoach travelers, vigorous canal traffic, and later the railroad to Lewistown. These converging modes of transportation created a thriving hostelry trade. Local histories also note that the Davis House was the site of the Lewistown lodge of the Knights of Pythias when it organized here in 1870. (Courtesy Mifflin County Historical Society.)

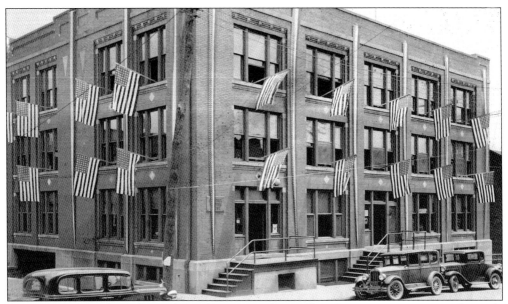

Local newspapers have been the public venue for Mifflin County citizens since the early days. This 1930s photograph shows the Lewistown Sentinel building on South Dorcas Street. Henry J. Fosnot founded the newspaper in 1903, guiding it for decades. Its predecessors included the *Lewistown Republican and Workingman's Advocate* (founded in 1832), the *True Democrat* (founded in 1845), the *Democrat and Sentinel* (founded in 1879), and the *Daily Sentinel* (founded in 1903). (Courtesy Mifflin County Historical Society.)

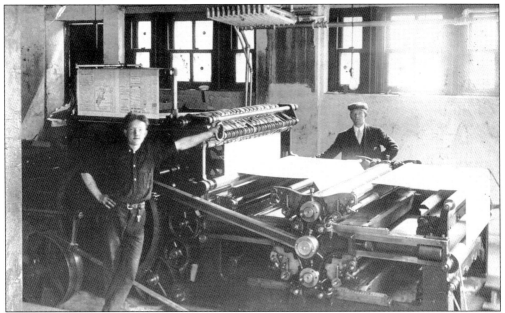

The *Lewistown Sentinel* was published in 1914 on what was considered the latest in printing technology at the time. Shown is the flatbed press at the newspaper's Dorcas Street facility, with pressman Arthur Pitman (left) and associate editor Nevin F. Gutshall. The newspaper remains Mifflin County's only daily but is no longer located in this building, which now is the home of the Salvation Army. (Courtesy Mifflin County Historical Society.)

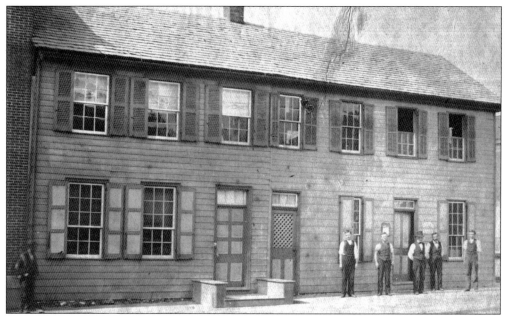

The *Lewistown Gazette* also served the county, and like other contemporary publications, took an overtly political stance serving the cause of the Republican Party. This is the newspaper's office at 26–28 North Main Street around 1870. The building housed the editor's home and the newspaper's office. Standing, from left to right, are Dave Unangst, ? Junkins, editor George Frysinger, George Hellman, and Charles Marks. (Courtesy Mifflin County Historical Society.)

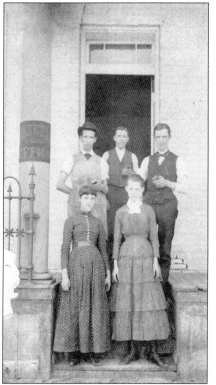

The Stackpole family bought the *Lewistown Gazette* in 1884, the time that this photograph was taken. In 1811, the newspaper started as the *Juniata Gazette* and later changed to the *Mifflin County Gazette and Farmers' and Mechanics' Journal*. Other name changes occurred. Shown here, from left to right, are (first row) Hallie Stackpole and Maggie Schell; (second row) John Thrush, Andrew Milligan, and George Stackpole. (Courtesy Mifflin County Historical Society.)

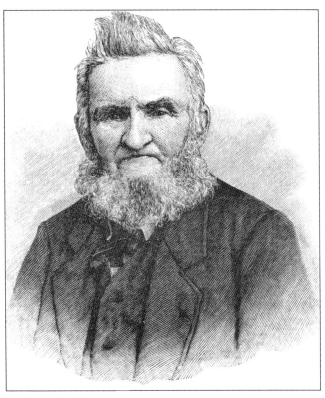

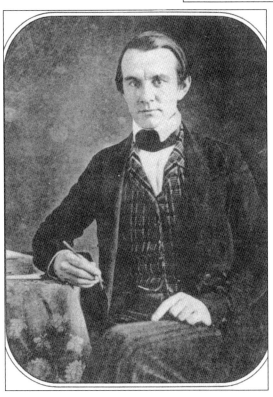

In 1886 at age 93, William P. Elliott was the oldest living newspaper publisher in the United States, having started what became the *Lewistown Gazette* in 1811. Born in Lewistown in 1793, an avid reader, Elliott attended local schools. Besides publishing, he was appointed Lewistown postmaster during the presidential terms of William Henry Harrison and John Tyler. He and his wife, Emily Smith, had 14 children. One of his children, Richard Smith Elliott, became editor of the *Gazette* at age 18. The younger Elliott's autobiography, *Notes Taken in Sixty Years*, is one of the most concise descriptions of Mifflin County life during the early decades of the 19th century. He also created the first political campaign symbol, the log cabin icon for William Henry Harrison's successful 1840 presidential run. (Above, courtesy Mifflin County Historical Society; left, courtesy Mark L. Gardner.)

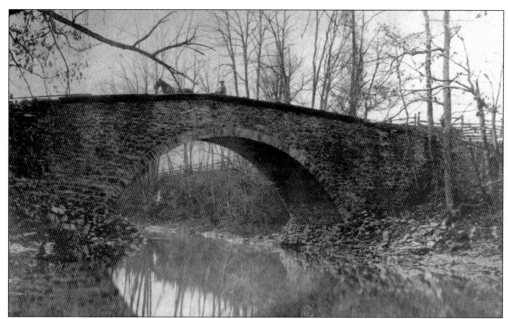

It has been a part of Mifflin County for almost 200 years. It serves as, perhaps, one of the most recognizable symbols of the county's rich heritage. It is the Old Arch bridge over Jack's Creek in Lewistown, shown here in the late 1880s. A nearby Pennsylvania historical marker records that the restored bridge was built in 1813 as part of the Harrisburg to Pittsburgh turnpike. (Courtesy Mifflin County Historical Society.)

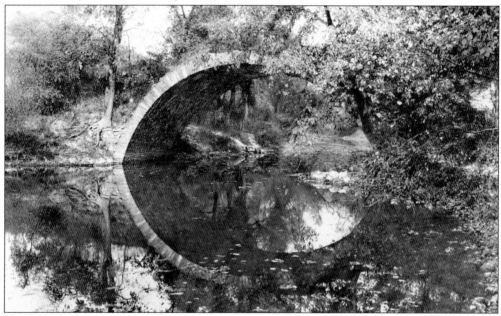

The bridge fell into disuse and was abandoned as part of the transport system, especially when the highway bypassed the old bridge in favor of a more efficient route. The reflected image of the bridge in this 1926 Kepler Studio photograph clearly shows that only the arch itself remained. The bridge's unique feature was that it was constructed without a keystone at the arch's apex. (Author's collection.)

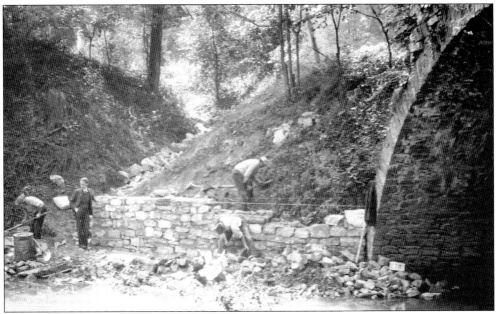

Deeds show that in 1929, Lewistown photographer Luther F. Kepler Sr. purchased property that included the bridge's eastern abutment. In an attempt to stabilize the arch before it gave way, Kepler began building a retaining wall in 1930 to shore up the old bridge. Workmen shown here complete masonry work during restoration. Kepler's brother, business partner and photographer James A. Kepler, is second from the left. (Author's collection.)

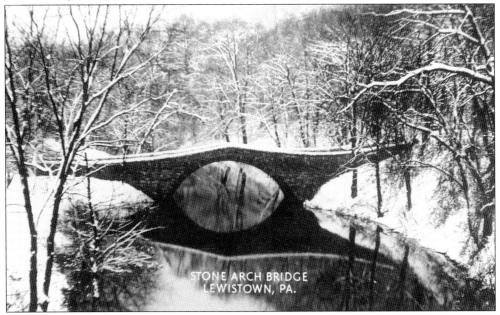

STONE ARCH BRIDGE
LEWISTOWN, PA.

A restoration was completed to save the bridge. Again in the 1940s, additional work was finished, shown in this contemporary postcard. In 2007, the county commissioners oversaw a thorough structural refurbishment and rededicated the Old Arch bridge. County historian Daniel M. McClenahen commented at the ceremony that the structure was "a bridge to Mifflin County's heritage and to our past." (Author's collection.)

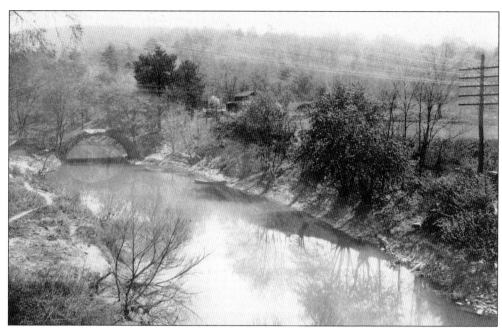

The 1929 photograph shows Jack's Creek and the Old Arch bridge prior to any restoration. The area to the right of the creek is the property of Luther F. Kepler Sr. and was purchased from the J. Miller estate that year. A house and some of the undeveloped property, as well as the deteriorated bridge, are visible. Kepler's plan was to develop the area into a neighborhood, incorporating the bridge in the design. In a time before digital imaging, the Lewistown photographer used some 1920s darkroom magic to visualize his concept of Arch Bridge Acres. Little stone bungalows with neat yards and driveways remained his goal for the development. However, it was a project that never came to fruition, only this image remains of what might have been. (Author's collection.)

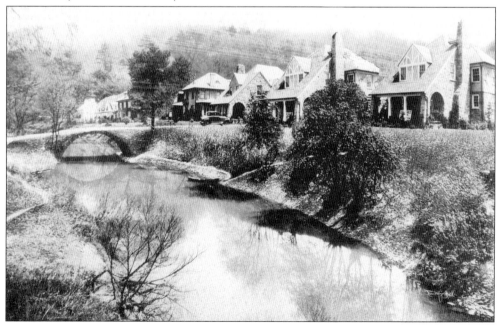

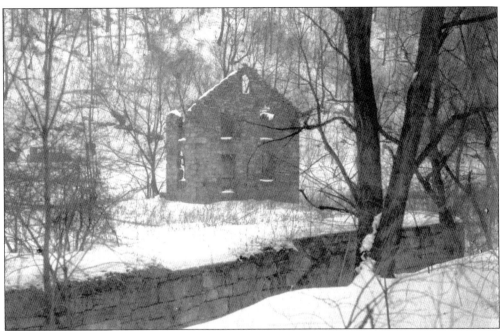

When these photographs were taken in 1926 of the lockkeeper's house and canal locks along the old Pennsylvania Canal at Lewistown, almost a century had passed since the water-filled ditch was first constructed there. It was the engineering marvel of its day and brought large numbers of workers into the county. Pay ranged from 50¢ to $1 per day for common laborers and up to $12 or $18 for stump pullers. In addition to the regular pay, each contractor furnished his workmen with a certain number of jiggers per day, or so many drinks of whiskey. Known as the Juniata division of the Pennsylvania Canal, the 45 miles of canal from Duncan's Island near Harrisburg to Lewistown was bid on July 15, 1827, and was completed in 1829. (Courtesy Mifflin County Historical Society.)

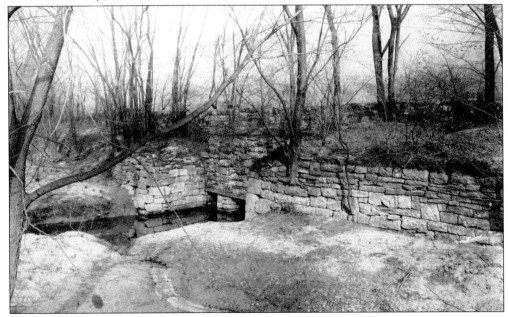

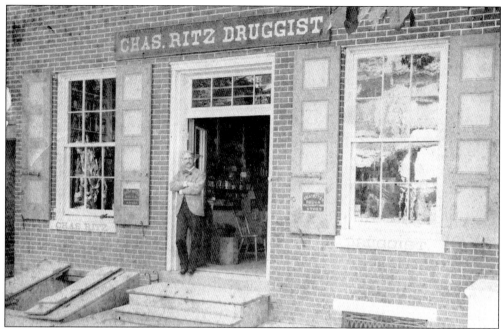

Charles Ritz was the canal workers' friend. One account tells that the laborers on the canal purchased quinine from Ritz, and placing as much as a large spoonful of the bitter medicine in the palms of their hands, they tossed it into their mouths before leaving the store. Ritz, shown here, opened his drugstore on Market Street in Lewistown in 1827. His apothecary occupied a log building built around 1787. In 1842, Ritz replaced the log structure with a brick building. *Lewistown Gazette* editor George Frysinger remembered the Ritz building in 1900, "When Mr. Ritz built the brick house he used the lock, hinges and bolts, all English made goods, and the double door also, of the old log house for the new store room." (Courtesy Mifflin County Historical Society.)

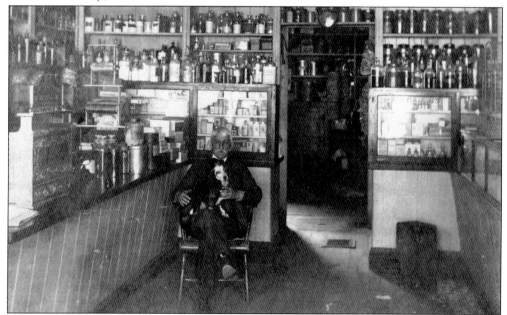

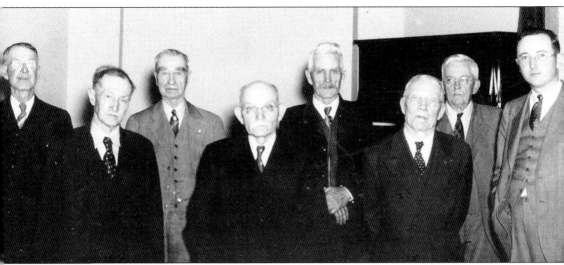

The heyday of canal travel lasted hardly more than 25 years. Railroads and then highways eventually dominated transportation. Pennsylvania disposed of its canals to private companies by the 1860s. On April 9, 1940, the Mifflin County Historical Society and the local Kiwanis club teamed up to host these veteran canal workers in the Coleman Hotel ballroom. The gathering came some 50 years after the Juniata division of the Pennsylvania Canal ceased operation following the flood of 1889. Pictured, from left to right, are Louis Peck of Lewistown, Capt. Monroe Craig of Newton Hamilton, Capt. J. Parks Murtiff of Lewistown, William Crimmel of Lewistown, John Rowe of Lewistown, Thomas J. Foreman of Lewistown, Amos Fry of Mexico in Juniata County, and Dr. S. K. Stevens, a historian from the Pennsylvania Historical and Museum Commission and secretary of the Pennsylvania Federation of Historical Societies. (Courtesy Mifflin County Historical Society.)

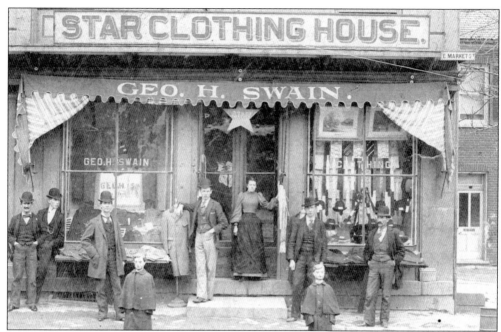

Lewistown had a diverse collection of businesses during the century from 1860 to 1960. The Star Clothing Store on East Market Street near the square, owned and operated by George H. Swain, claimed in the 1890s to be the largest clothing house in Mifflin County, specializing in made-to-order clothing. The street mannequins were unique advertisements, as they were not seen in other photographs of the period. (Courtesy Mifflin County Historical Society.)

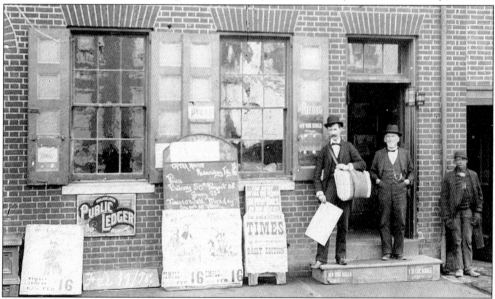

W. C. Dyer Stationary Store was located at 25 East Market Street in this 1898 photograph. Dyer wears the derby hat at left, the man in the middle is unidentified, and James (Jimmer) Gibbons is at right. A Temple Opera House advertisement under the window lists a show for Wednesday, February 16, 1898, with seating prices ranging from 25¢ to 50¢. (Courtesy Mifflin County Historical Society.)

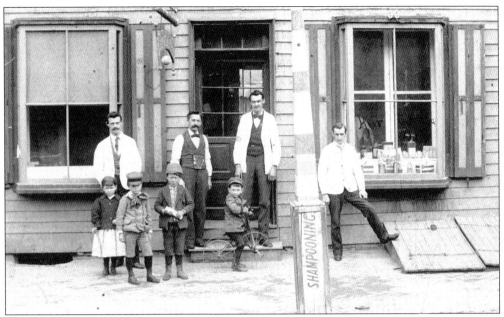

Barber Peter Drayer advertised "easy shaves, fashionable haircuts, and polite attention always" in an 1894 publication. He proudly asserted that he had been in the barbering business longer than any other Lewistown barber. He stands outside his tonsorial parlor on East Market Street in this 1890s image. Drayer is the mustached man with vest and watch chain to the left of the door. (Courtesy Mifflin County Historical Society.)

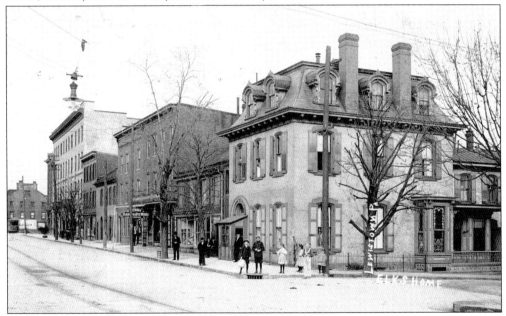

This early-1900s photograph looks east on West Market Street toward the square. The corner structure was the residence of A. E. Reed, superintendent of the Lewistown division of the Pennsylvania Railroad. Later acquired by the Lewistown lodge of the Benevolent and Protective Order of Elks, the building became an orphans' home before it was razed and replaced in 1929 by Elks lodge No. 663. (Courtesy Ernest Solt.)

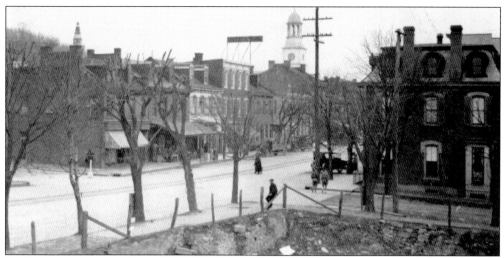

Still on West Market Street, this mid-1920s photograph offers a view of the other side of the street from the site of the former St. Charles Hotel. The old hotel was removed to make room for the new federal building, constructed to house the Lewistown Post Office, which local authorities and organizations had wanted for over a decade. (Courtesy Mifflin County Historical Society.)

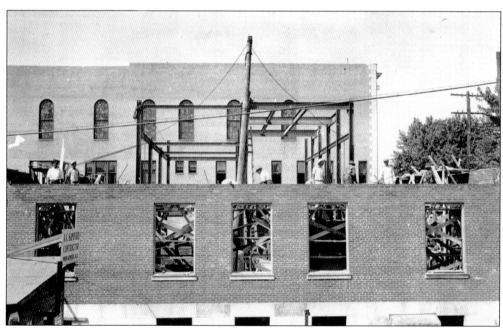

Construction began in 1927, and the federal building was ready for occupancy during the first week of January in 1928. Contractor A. C. Samford of Montgomery, Alabama, constructed the main building of red tapestry bricks, Indiana limestone, reinforced concrete, and steel. Cost of the building was $88,825, which, with additions, came to a total cost of just under $93,000. (Courtesy Mifflin County Historical Society.)

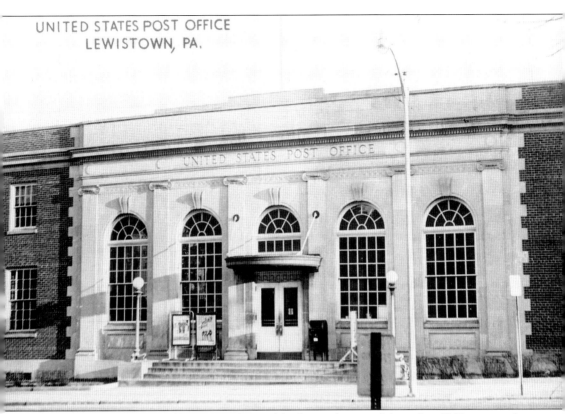

UNITED STATES POST OFFICE
LEWISTOWN, PA.

The finished building is still in use today and looks much as it did in this 1940s postcard. In 1798, Pres. John Adams commissioned Mifflin County's first postmaster, Jacob Walters. A blacksmith by trade, Walters served as postmaster for 30 years. His home was located where the Masonic temple building remains today. When he died in 1828, his daughter Margaret J. Walters replaced him. Having grown up while her father served as postmaster, she was well acquainted with the mail service. She married E. L. Benedict, Esq., in 1835 and resigned her position, since a married woman with a career was not the custom of the era. She is, however, believed to be the first woman in the United States to serve as a postmistress. (Courtesy Mifflin County Historical Society.)

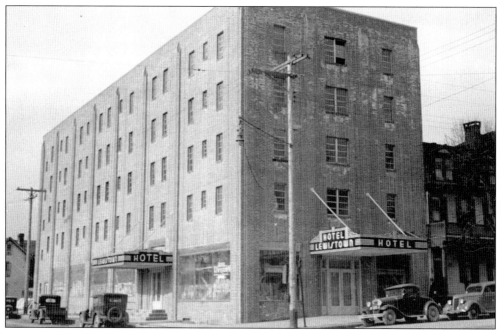

The Hotel Lewistown was a new building when this photograph was taken in 1937. The establishment touted the fact that, as a reinforced concrete structure, it was virtually fireproof. It stands on the west corner of South Main and West Water Streets on the site of Arthur and Dorcas Buchanan's log tavern that was built in the 1700s. (Author's collection.)

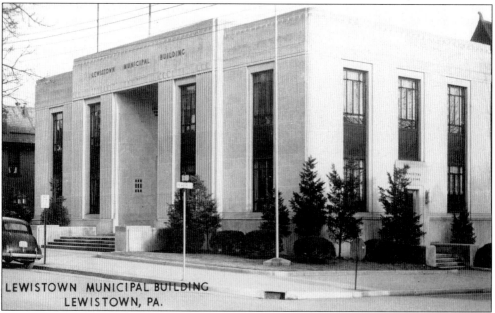

Lewistown's original borough building, referred to in earlier accounts as the town hall, was razed in 1935 to make room for this $65,000 edifice, completed in July 1937. The structure's design is typical of Depression-era Works Progress Administration projects, of which the Lewistown Borough Municipal Building was. It still stands and serves the municipality today. (Author's collection.)

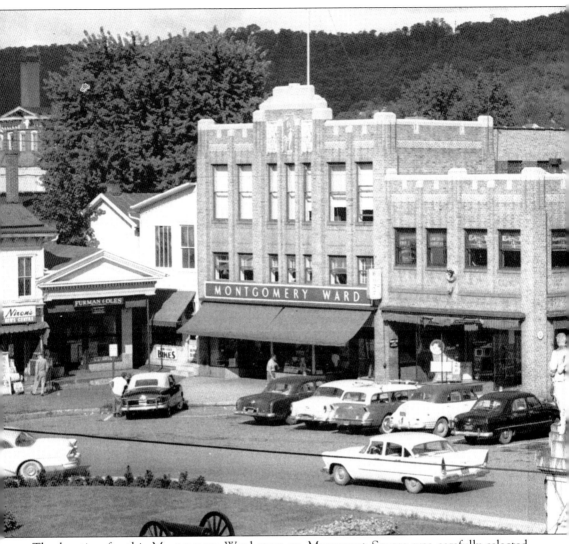

The location for this Montgomery Ward store on Monument Square was carefully selected before the art deco building was constructed in 1929, according to company officials as reported in the local newspaper. Montgomery Ward was not expecting the town proper to sustain the new store; rather it was rural customers who were the real target. A company spokesman told the *Sentinel*, "We count the number of automobiles parked in the city on Saturdays or other popular trading days as indicative of the popularity of the city as a trading point for rural customers. We are coming here because we believe the people of the vicinity prefer to trade in Lewistown." The building, shown here in the 1950s, is on the National Register of Historic Places based on its architecture and the fact that it is one of the company's first stores. To the right of the store, at the time, was radio station WMRF, the county's oldest station, first broadcasting in 1941. (Courtesy Mifflin County Historical Society.)

As early as 1804, Lewistown established a school on a lot on West Third Street. Accounts tell that it was built of round logs with an occasional pane of glass fitted between the logs for light. A nine-plate stove heated the structure but terminated in a loft above the classroom where the smoke escaped between the logs above. This is the second school, built in 1809 on the same location. (Courtesy Mifflin County Historical Society.)

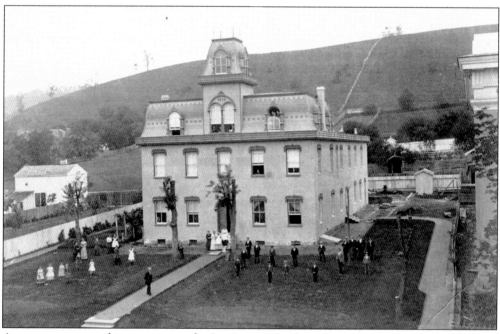

An act was approved incorporating the Lewistown Academy in 1815. Along with the students paying tuition, the act allowed for the institution to accept five poor children to be admitted free for a term not to exceed two years. This photograph shows the academy in 1872 on the north side of East Third Street. (Courtesy Mifflin County Historical Society.)

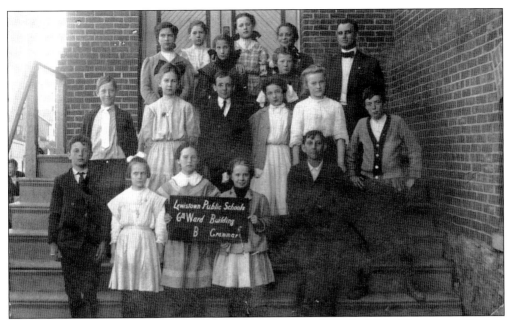

Sixth Ward grammar students pose for their photograph in the early 1900s. The unnamed group represents scores of county students who attended schools following the 1834 Free School Act. When the act passed, Mifflin County's share for all schools to be established across the county was $625.52. In 2007, Mifflin County's one-county system had a $50 million budget. (Courtesy Ernest Solt.)

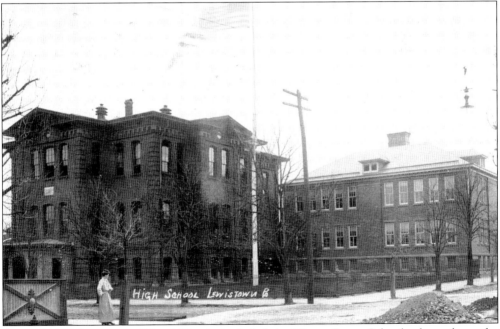

Around 1909, Lewistown School District included the Wayne Street Schools, shown here, the Sixth Ward School, and a school on Logan Street. Eventually the Toll Gate School and Seventh Ward School were added. The Occupational Education Building was built in 1905, and a new high school was constructed in 1917 and expanded in 1937. (Courtesy Ernest Solt.)

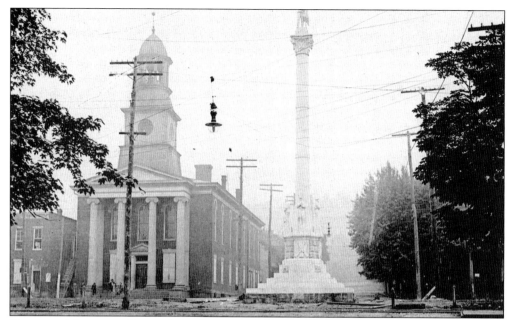

Known as Monument Square from the time of this June 1906 photograph, this memorial was intended to honor the memory of the soldiers and sailors who fought and died in the Civil War. As early as the end of the conflict, civic leaders agitated for a significant monument to the county's participants. It took decades to raise the necessary funds. (Courtesy Mifflin County Historical Society.)

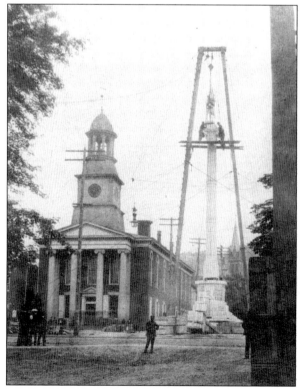

The finishing touches are added to the Soldiers' and Sailors' Monument shortly before the dedication. Made of Vermont granite, the completed monument tipped the scales at 125 tons and was 64.5 feet high. The four sides of the monument display designs of the branches of the military at the time of the war—navy, infantry, artillery, and cavalry. (Courtesy Mifflin County Historical Society.)

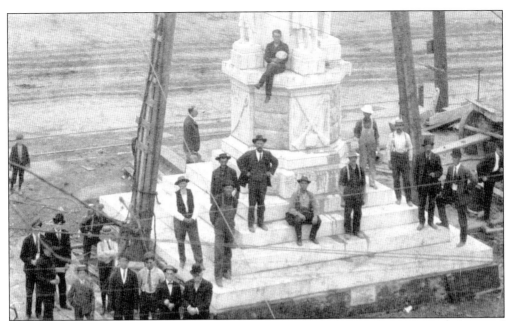

Workmen from Lewistown contractor D. R. Stratford and men from the Moore Brothers and Brault Company, who were granite manufacturers from Barre, Vermont, take a much deserved break after setting the finishing touches on the Soldiers' and Sailors' Monument. A special stone from the tomb of Pres. Abraham Lincoln can be seen as a white rectangle in the base. (Courtesy Mifflin County Historical Society.)

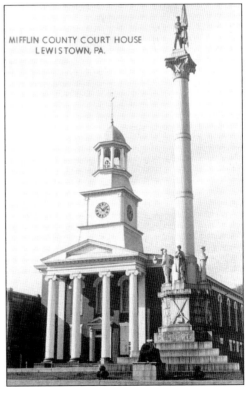

This view of Monument Square has become a symbol of the county, used on the Lewistown borough's official seal and as part of many local organizations' logos. The only stone removed from Lincoln's tomb in Springfield, Illinios, was placed in the monument's base in 1906. It was given in recognition of Mifflin County's Logan Guards, who were the first defenders to answer Lincoln's call for troops in April 1861. (Author's collection.)

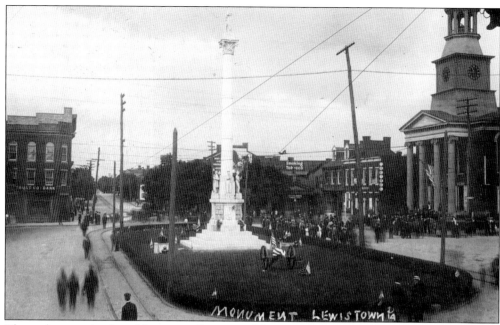

These photographs show Monument Square on Memorial Day 1910, when the long guns at the memorial were officially presented. Earlier two large mortars were received by the monument committee from the war department and were securely placed on the north and south sides of the monument. An act of Congress was necessary, supported by the county's member of Congress the Honorable Benjamin K. Focht, to allow two 12-pound bronze gun tubes to be donated from the U.S. Arsenal at Watervliet, New York. The tubes were delivered to Col. Hulings Post No. 176, the local post of the Grand Army of the Republic. Metal gun carriages to mount the tubes were made in Gettysburg by Calvin Gilbert, the maker of the military park's similar gun carriages, at a cost of $200. (Above, courtesy Ernest Solt; below, courtesy Mifflin County Historical Society.)

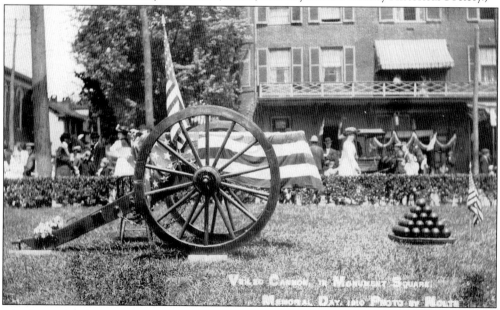

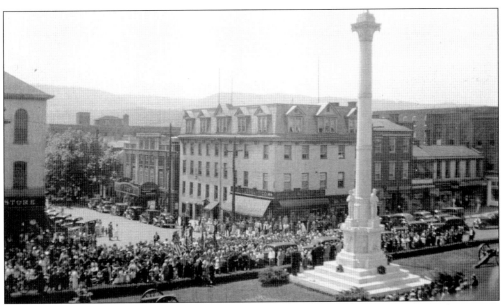

Monument Square has been the focal point of numerous celebrations as well as somber events since its completion in 1906. The photograph above shows the square during a Memorial Day service in the 1930s, with wreaths placed on each of the four sides of the memorial. City Hook and Ladder Fire Company had cleaned the memorial using pressure hoses and the company's high ladder. The photograph below was taken in 1940, as Mifflin County welcomed the 66th annual Pennsylvania State Firemen's Convention that ran from September 30 to October 3. The United States flag in the square is flying at half-staff, due to a tragic event that occurred when a fireman was killed during a high ladder demonstration in downtown Lewistown. Fire equipment circled the north portion of Market Street in front of the courthouse. (Courtesy Mifflin County Historical Society.)

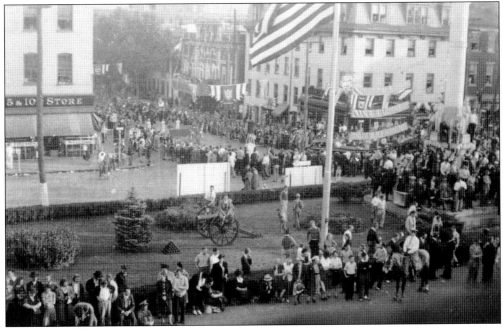

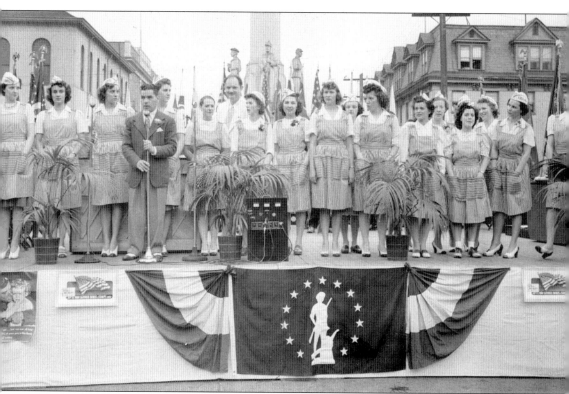

Monument Square was the site of a World War II bond drive titled "Victory Mardi Gras" in 1942. A young Hollywood actress named Gloria Stuart and other entertainers came to town to help promote the event and raise money on the home front for the war effort. (In 1997, Stuart became known to new generations when she portrayed the aged Rose in the movie *Titanic*.) Shown at the microphone, the July 2, 1942, event had Embassy Theatre owner Harold D. Cohen as master of ceremonies. The ladies on the stage promoted and sold war stamps and bonds at various restaurants, businesses, and factories where they worked throughout the county. Their efforts totaled $21,825. Appearing here, from left to right, are Helen Wetzler, Alice Massey, Doris Bailey, Harold Cohen, Mrs. Leonard Aurand, Mrs. Robert Adams, John Wilson, Josephine Stewart, Julia Cewlla, Betty Knudson, Mrs. James Benfer, Jane Manbeck, Mrs. Neva Gracey, Mrs. Charles Miller, Betty Lou Brown, Mrs. DeWitt Bearley, Christine Brandt, and Lois Arnold. (Courtesy Mifflin County Historical Society.)

The inscription on the back of this photograph states, "The Dirigible Los Angeles passing over Lewistown May 30, 1928. Rainy Weather," and bears the signature of Stanley H. Shontz. The *Los Angeles* was built in Germany, partially funded by German World War I reparations. From 1925 to 1931, the *Los Angeles* made several cross-country flights around the eastern and southern United States, including this one over Monument Square. (Courtesy Ronald Aurand.)

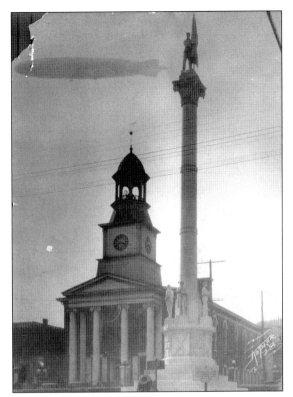

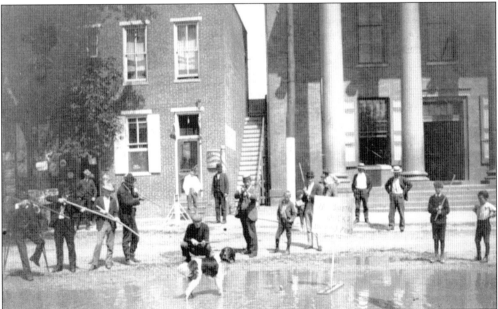

The *Lewistown Gazette* blamed the town council for allowing the "duck pond" to collect in the square, as seen in this June 1900 photograph. Construction of the trolley line contributed to the problem described by the newspaper as the "lake." Pool hall patrons came out to raise their cues in a mock duck hunt, complete with bird dog and decoy. (Courtesy Mifflin County Historical Society.)

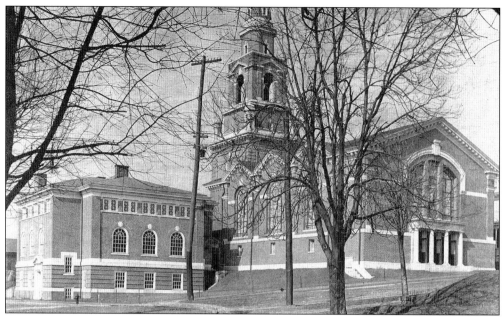

A Presbyterian congregation was formed in Lewistown about one year after Mifflin County was established in 1789. Since there was no church building, meetings were held outdoors or in the county's first courthouse. On this site, 17 East Third Street, a stone church was erected in 1820 and was torn down in 1854 to make room for a larger brick church. (Courtesy Mifflin County Historical Society.)

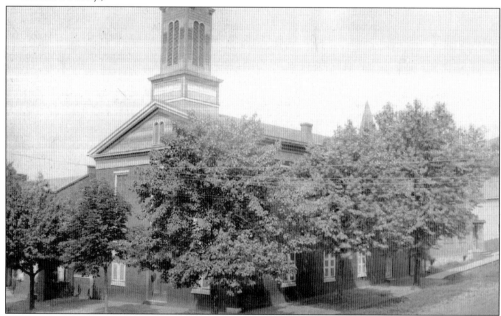

St. John's Lutheran Church was founded in 1798, building its first church in 1824 at 26 West Third Street. In 1850, the congregation started construction at 120 North Main Street, but that building burned before completion in 1852. It was rebuilt and dedicated in 1853. The tornado of 1874 blew down the church spire. The present building dates from 1902. (Courtesy Mifflin County Historical Society.)

A Methodist church has been on this site since 1830; however, circuit riders held Methodist meetings as early as 1802. The present structure was built in 1900 and included a massive Tiffany window, which faces the pulpit from the Dorcas Street side of the sanctuary. In the mid-1960s, the Tiffany window and the stained-glass window facing Third Street were covered with protective storm glass. (Author's collection.)

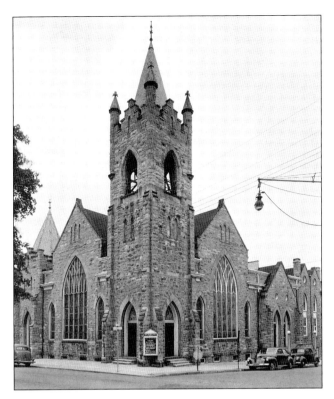

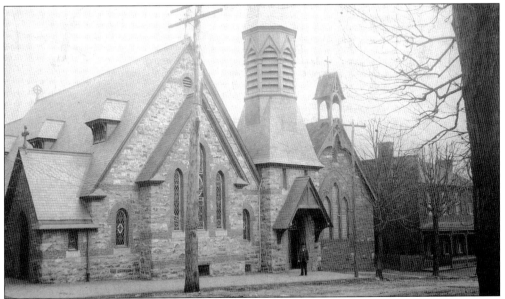

St. Mark's Episcopal Church, located at 21 South Main Street, has roots from 1824 when the first church was constructed. The structure combines the third church building that was built 1878 and 1879, now known as the parish hall, and the fourth church structure that was completed in 1899. The Gothic Revival architecture of the parish hall and the stone main church building are complemented by interior design elements maintained throughout its history. (Courtesy Mifflin County Historical Society.)

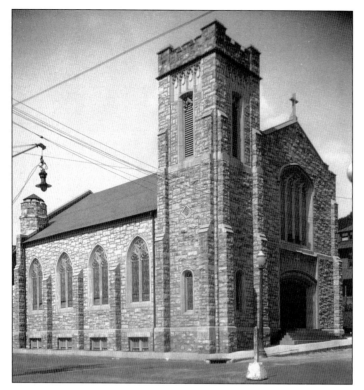

In 1827, the Catholic population of Lewistown petitioned church authorities in Philadelphia to request that a priest be sent to administer the rites of the church to the many laborers living here and working on the new Pennsylvania Canal. A chapel built in 1828 was dedicated as All Saints Church in 1830. This stone sanctuary, Sacred Heart of Jesus Catholic Church, was constructed in the 1920s. (Author's collection.)

On September 21, 1840, 11 members organized the First Baptist Church. The following year, with 30 members, the congregation was admitted to the larger organization known as the association. From 1871 to 1873, the Baptists worshipped in the Apprentices' Hall, in the town hall, and other locations. In 1881, the congregation constructed a brick chapel at this location on 111 East Third Street. (Courtesy Mifflin County Historical Society.)

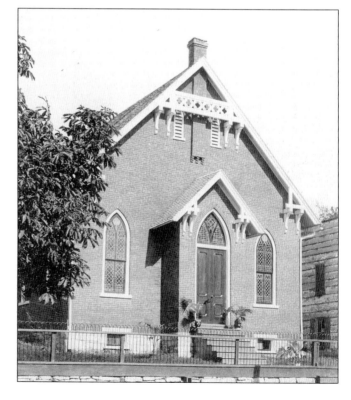

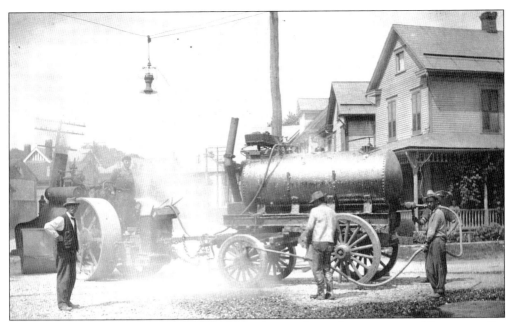

Repairing the streets of Lewistown around 1820 was a hot, oily proposition. The steamroller applied the necessary pressure to the macadam patch in the vicinity of Shaw Avenue. The remarkable feature that is not seen in this photograph is that these streets were originally paved with brick, which occasionally comes to the surface today during extensive removal of a street's pavement for underground work. (Courtesy Mifflin County Historical Society.)

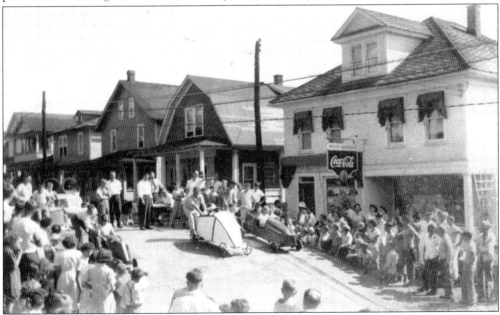

A Labor Day event in the 1930s, the soapbox derby, saw racers vying for prizes that ranged from $1 to $25, as entrants raced down a blocked-off Valley Street in Lewistown in homemade cars. Categories included the fast roller bearing–type cars and the slower wagon wheel variety. Several thousand watched annually as cars started atop Stratford's Hill and sped to the finish near Spruce Street. (Courtesy Ernest Solt.)

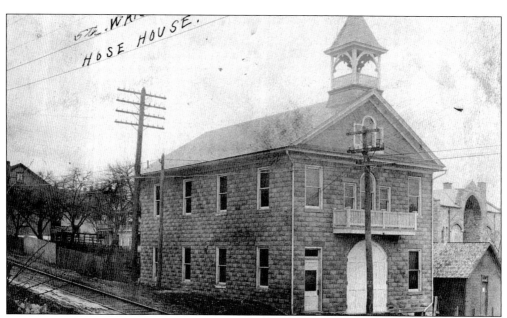

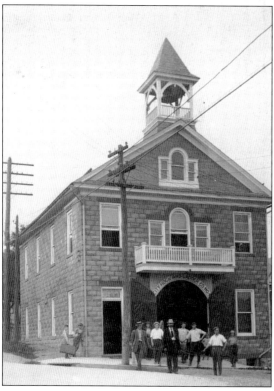

Mifflin County has a long history of volunteer fire companies. In 1940, Lewistown's volunteer companies included Henderson Fire Company No. 1, Fame Fire Engine Company No. 2, Brooklyn Hose Company No. 3, City Hook and Ladder Company No. 4, Junction Fire Company No. 5, and Highland Park Hose Company No. 6. This series of photographs shows how changes occurred over time and memories faded as to which company occupied what building and when. The view above shows the City Hook and Ladder Company's second firehouse, erected in 1906 on Lewistown's Valley Street at a cost of $3,350. The view at left shows this building about 10 years later, with the fire crew posing near the hand-pulled car. The company remodeled this building in 1939 and 1940. (Courtesy Ernest Solt.)

A few years later, a candy company and City Hook and Ladder Company No. 4 swapped buildings. The H. B. Goss Candy Company (shown in the 1930s) was located about a block down Valley Street from the city firehouse. It operated its fork-dipped chocolate candy operation there. Eventually the candy company moved into the old City Hook and Ladder Company building and City took over the candy maker's building. In more recent times, Goss Candy was acquired by Asher's and moved its operation from Valley Street; however, City Hook and Ladder Company still occupies the old H. B. Goss Candy Company building on Valley Street. (Author's collection.)

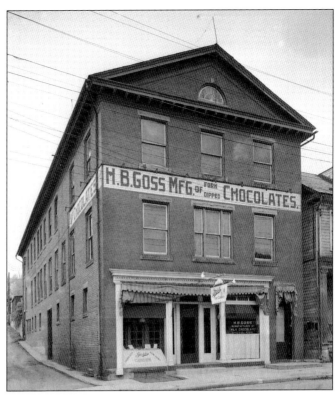

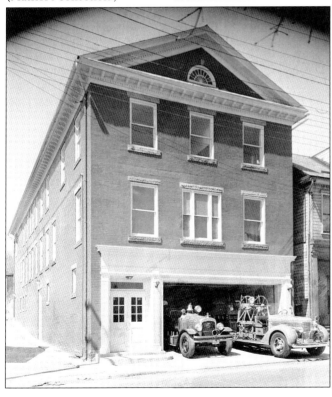

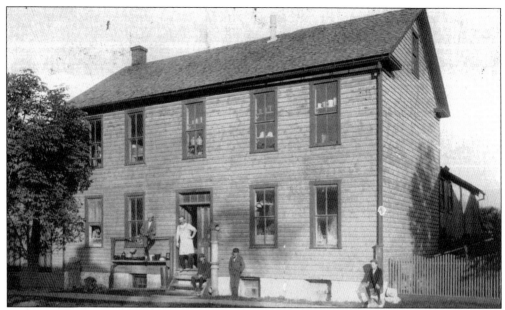

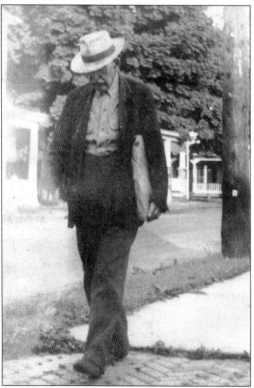

John H. Dipple settled in Mifflin County in 1848. He was a potter by trade and began to manufacture redware on Big Ridge near Lewistown. Dipple eventually moved to this site at 234 Valley Street in 1868. Crocks, jugs, bowls, and all types of pottery goods were handmade here. Dipple died in 1872 and his wife, Anna, continued with the help of sons John Jr. and Andrew Gregg Curtin Dipple, who was known as Curt. John Jr. died in 1906, and the business passed on to Curt, shown standing in the doorway (above). He ceased making hand-thrown pottery on site in 1938 but continued to deal in machine-made pottery products. The photograph at left shows Curt walking to work, even into his 90s. He died in 1952. His son John closed the business in 1962. (Courtesy Mifflin County Historical Society.)

The Moller brothers, Holger and Wilhelm, came to America in the early 1900s from Denmark to seek employment at Burnham's Standard Steel Works. However, the inventive businessmen were destined to manufacture their own product, the Moller car. Shown is the Regal model, on display at North Brown Street. They built automobiles here from 1919 to 1923. (Courtesy Mifflin County Historical Society.)

The Moller brothers' Falcon model offered a host of innovations for its $1,000 price tag. It boasted an aluminum body, tilt steering wheel, electric start, wire wheels, and got 50 miles to the gallon. By the mid-1920s, Ford was offering automobiles for about $300 and, with competition like that, Moller's car, though not the most expensive by any means, was still pricey. (Courtesy Mifflin County Historical Society.)

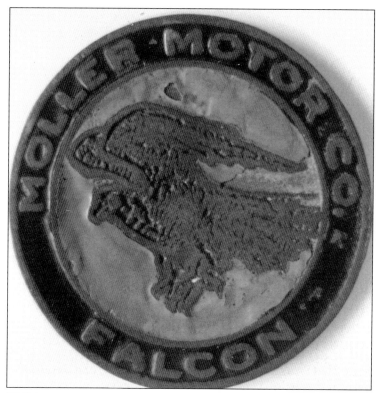

Perhaps the Falcon was before its time. Without the benefit of Ford's assembly line, the slow, handmade cars were produced one at a time and deliveries were stretched to seven months. The company moved to Maryland to be closer to a wider market and cut costs, but like many other manufacturers of the time, Moller closed, producing only about 1,000 automobiles in total. (Courtesy Mifflin County Historical Society.)

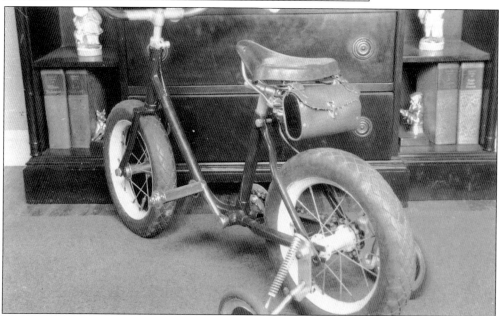

Wilhelm Moller was also a bicycle champion in his native Denmark. He and brother Holger operated a bicycle repair shop in Lewistown prior to the car manufacturing business. Wilhelm created this unique pair of training wheels, shown here in the Moller home, that were spring loaded to ease a novice rider over bumpy roads. The invention is on exhibit at the historical society's museum. (Courtesy Mifflin County Historical Society.)

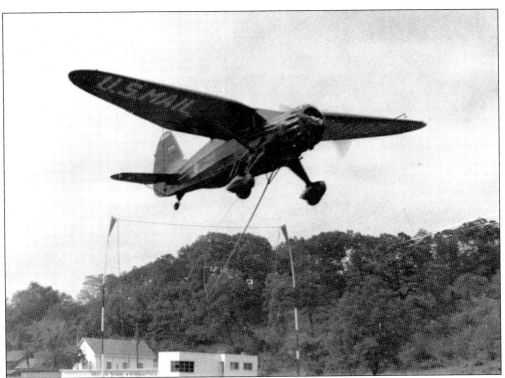

The first airmail pickup here on September 21, 1941, is shown. The letters, in a canvas bag, were hung between two poles at the Lewistown Airport by John B. Kratzer. The plane picked up 3,000 letters, destined to reach Harrisburg in some 26 minutes. Inside the plane, a worker sorted the mail during the flight. During another flyover, mail was dropped from the plane, via canvas bag, for local delivery. Officials present at the inauguration of the Airmail Pickup Service at Lewistown Airport, from left to right, are Byron W. Skillin (traffic manager, All American Aviation), William Cramer (Mifflin postmaster,) Charles McClellan (Mifflin postal clerk), G. T. Wills (agent, Railway Express Agency), John B. Kratzer (airmail messenger), Dr. J. C. Amig (Lewistown postmaster), Crawford B. Cramer (assistant Lewistown postmaster), C. R. Hoffman (superintendent of mails), Joseph P. Riden (money order clerk), and Henry A. Wise Jr. (secretary and head of legal department of All American Aviation). (Courtesy Mifflin County Historical Society.)

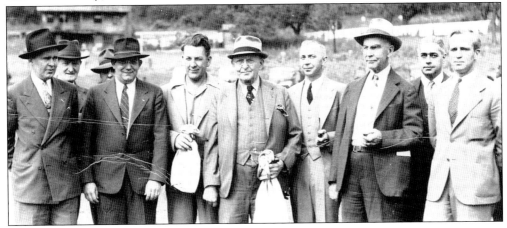

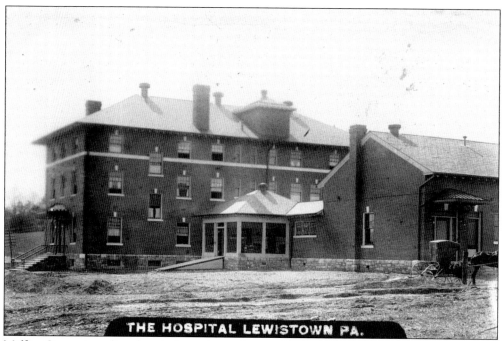

THE HOSPITAL LEWISTOWN PA.

Mifflin County's earliest hospital was located near the Lewistown railroad station to enable access by rail to larger hospitals in Harrisburg or Philadelphia. Doctors made house calls or patients came to a practitioner's office when sick or injured. The Lewistown Hospital opened in 1905, and a nursing school started in 1908 at this location in the Highland Park section of Lewistown. The photograph above shows the hospital around World War I. Note the horse and buggy hitched at the side of the building (at right). The original building cost $60,000, of which $12,000 came from the Commonwealth of Pennsylvania and about $30,000 from a community-wide subscription. A Women's Aid Society was established to complete auxiliary work to maintain the hospital. The photograph below shows the facility with the addition of the dispensary or emergency room prior to World War II. It was remodeled in the 1950s, again in the 1970s, and most recently in 2002, including a pad for emergency air flights via helicopter. (Courtesy Ernest Solt.)

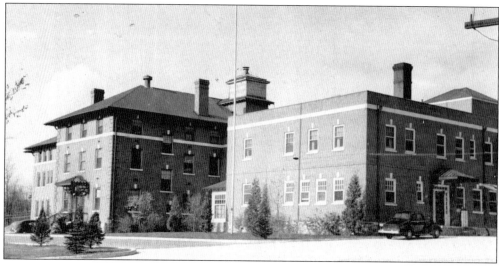

Three

AROUND THE COUNTY

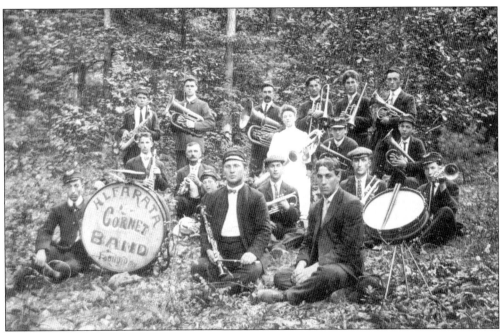

Mifflin County has 10 townships and six boroughs. The townships, listed according to the date of founding, include Derry, Armagh, Wayne, Union, Oliver, Brown, Menno, Granville, Decatur, and Bratton. Scattered throughout these municipalities are dozens of little hamlets and villages. The scope of this book cannot reach them all, but an overview of their diversity will emerge. Alfarata is typical of these hamlets and villages, represented by its community band shown here around 1910. (Courtesy Mifflin County Historical Society.)

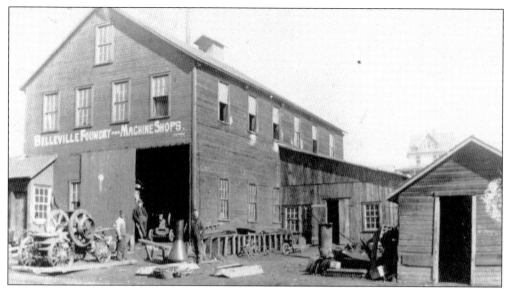

Union Township came into being in 1790 and was the first township established in the newly formed Mifflin County. Its name honors the original 13 states of the fledgling United States. Belleville is its principal village. The Belleville Foundry and Machine Shops, shown here, represents the community's important agricultural manufacturing plant started by Hertzler and Zook in the 1800s. (Courtesy Ernest Solt.)

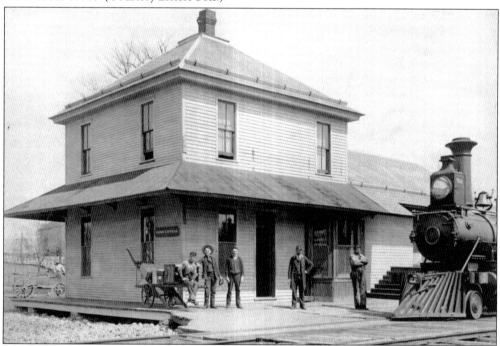

The Kishacoquillas Valley Railroad, known as KVRR (or "KV" to the locals), had its origins in Belleville in the 1890s under the driving force of one of its founders, Dr. John P. Getter. Shown here is the station from which farm produce and those who grew it could catch the train to and from Belleville. The railroad served the public for 47 years, from 1893 to 1940. (Courtesy Mifflin County Historical Society.)

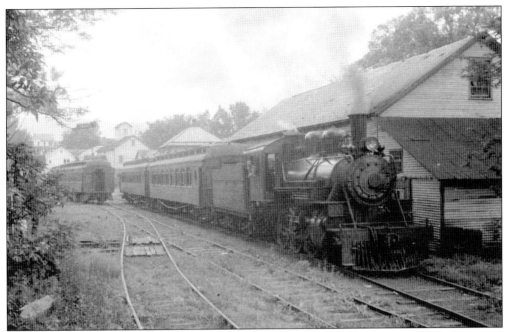

The Belleville Mill is seen in the background, as a KVRR train moves out in the 1930s. Improved roads and efficient trucks and automobiles doomed the rail line, stealing both its passengers and freight. February 1940 marked the final run of the KVRR. Most of the rails and rolling stock were eventually scrapped for the war effort in the 1940s. (Author's collection.)

Belleville's Main Street, shown here in the early 1900s, would become Route 655 through the Kishacoquillas Valley, also locally called Kish Valley or Big Valley, opening traffic and commerce to this productive agricultural area. Amish and Mennonite farmers in this area of Mifflin County make up one of the most diverse communities of Plain People in the United States. (Courtesy Ernest Solt.)

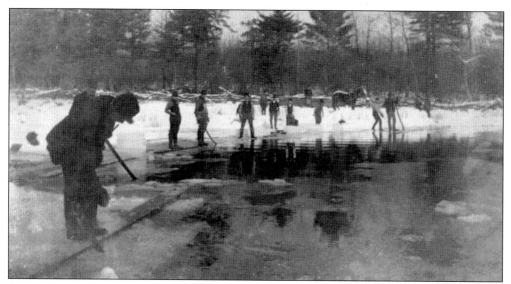

At one time, ice harvested in winter months was stored away in an icehouse for use in the summer months. This scene is from near Allensville, located southwest of Belleville, from around 1910. Allensville, established in 1837, is located in Menno Township and named for Menno Simon, founder of the Mennonite religious sect. Mennonites, represented by a number of churches and private schools, live in Kish Valley. (Courtesy Ernest Solt.)

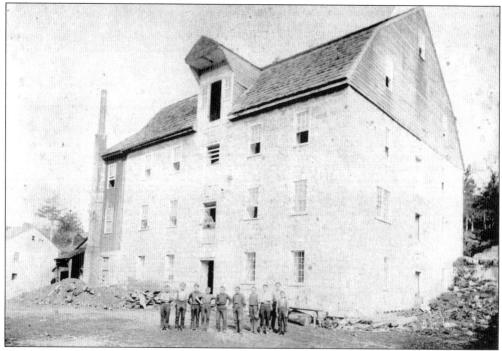

The Allensville Mill is shown here in the early 1900s. It was an essential part of the farming community around it. Allensville was named for early settler Chris Allen, who bought land in the area in 1806. Its original name was Horreltown or Horrelton, and it was part of a land grant given to Andrew Montour for services rendered at the time of the French and Indian War. (Courtesy Ernest Solt.)

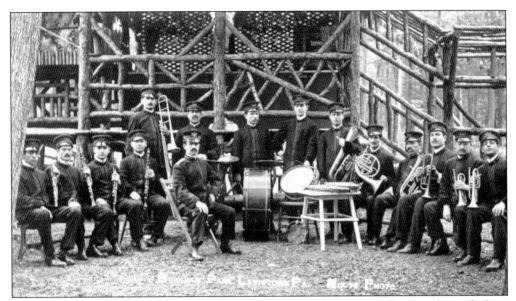

Burnham Park, shown here in the early 1900s as a band readies to play, was located along the trolley line of the Lewistown and Reedsville Electric Railway. The trolley line began in 1900, while Burnham Borough was incorporated on June 21, 1911. The town grew up around the iron-and-steelworks there and in the 1880s was named for William Burnham, an official at the steelworks. (Courtesy Ernest Solt.)

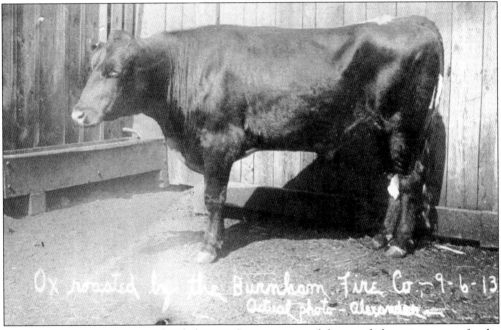

The Burnham Fire Company decided to purchase a new truck but needed to raise money for the acquisition. A novel fund-raising idea was conceived in the form of an old-fashioned barbecue, when this poor beast was to be the guest of honor at an ox roast held on September 6, 1913. This real-photo postcard was distributed to stir interest in the event. (Courtesy Ernest Solt.)

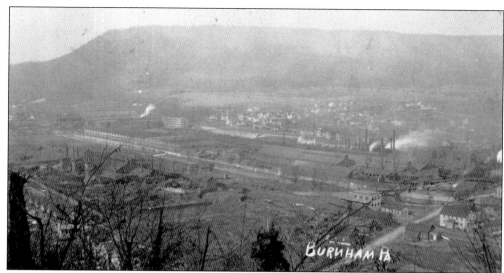

The panoramic view above shows Burnham beyond the iron- and steelworks that employed the many residents of the community surrounding the sprawling industries. To the right foreground, Logan Iron and Steel Company, which employed 524 workers at the time of World War I, is visible. Standard Steel Works employed over 3, 500 at about the same time. Both companies experienced a boom during the next war. Standard Steel Works was vital to the war industry during World War II. A ceremony during that war near the main gates of the plant is shown here. Logan Iron and Steel Company was sold after the war, and its property is now occupied by a salvage industry. Standard Steel Works experienced setbacks but reorganized as a division of the Freedom Forge Corporation. Away from the bustle of industry, Burnham has many quiet, residential neighborhoods. (Courtesy Ernest Solt.)

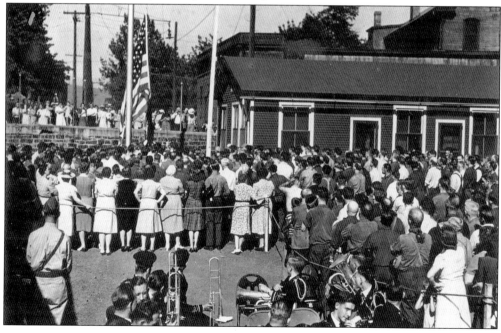

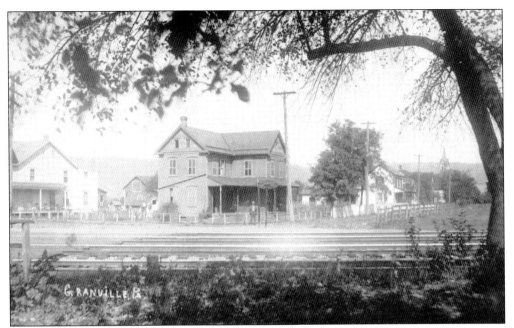

Granville was a station along the main line of the Pennsylvania Railroad, shown here in the early 1900s. The village is located in Granville Township, formed in 1838, and named for either Fort Granville of French and Indian War fame or Granville Penn, a relative of William Penn. (Courtesy Ernest Solt.)

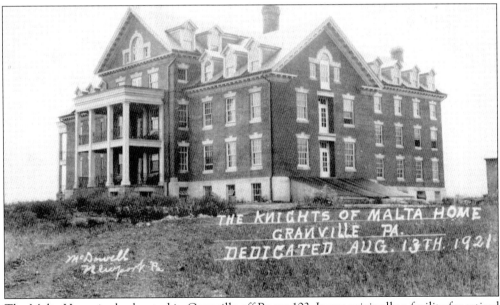

The Malta Home is also located in Granville off Route 103. It was originally a facility for retired or ill members of the Order of the Knights of Malta and was dedicated on August 13, 1921. Over the years, it served as a retirement home for many local citizens. Now called Malta Home for the Aging, the facility is at maximum capacity. (Courtesy Ernest Solt.)

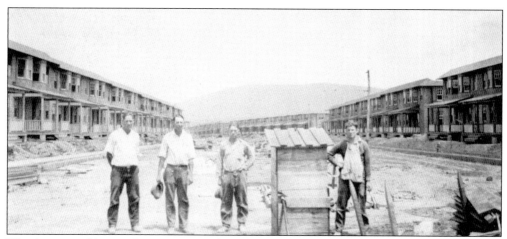

The American Viscose Corporation, maker of artificial fabrics, built a planned community for its employees called Juniata Terrace across the river from Lewistown in what was then Granville Township. Hundreds of housing units were constructed. Construction is well underway in the above photograph, and the completed community is visible in the one below. The company began construction in 1920, and in 1921, the nearby Viscose plant opened for business. The company finally decided to divest itself of the town. In 1968, the residents petitioned the county court to allow the town to incorporate. The petition was granted, and Juniata Terrace became Mifflin County's youngest borough. The Viscose plant employed thousands, but its location along the Juniata River was a detriment due to flooding. The 1972 flood caused its closure. (Above, courtesy Mifflin County Historical Society; below, courtesy Ernest Solt.)

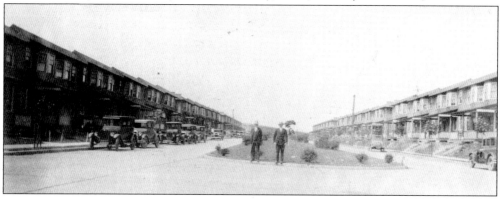

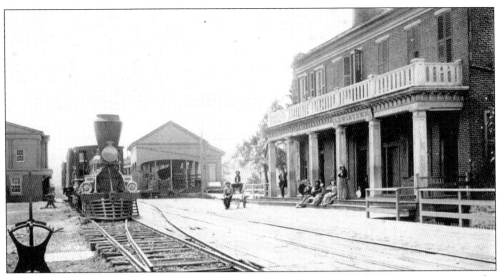

Lewistown Junction, seen here in the 1860s, was the location of the town's station on the Pennsylvania Railroad. As far as is known, the station is the oldest surviving structure built by the Pennsylvania Railroad. This station was constructed in 1848 and 1849 and was the location, on September 1, 1849, of a celebratory banquet for the opening of the railroad to Lewistown. (Courtesy Mifflin County Historical Society.)

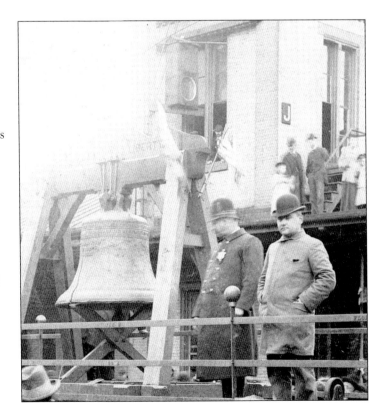

Perhaps the most famous relic to stop in Mifflin County is the Liberty Bell, shown here on its way to the 1893 World's Columbian Exposition in Chicago. Thousands gathered at the station. When the bell arrived in an open car, a band played the "Star Spangled Banner." People passed their babies forward to have attendants press the children against the relic. (Courtesy Mifflin County Historical Society.)

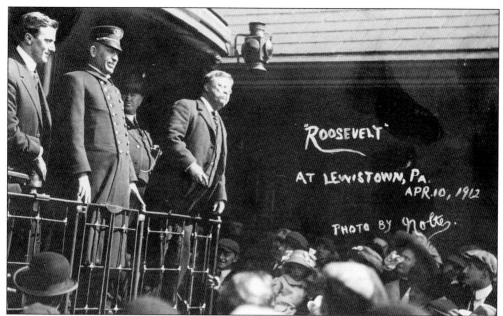

Presidents came to the station, like Harry S. Truman, Dwight D. Eisenhower, Richard M. Nixon, and others. Whistle-stop campaigning was the vogue. Here is Theodore Roosevelt, a former president at the time, pressing his points to the crowd during his third party drive for the presidency in 1912. He had his special train stop in the Long Narrows to see the site of an armed train robbery that happened there in 1909. (Courtesy Mifflin County Historical Society.)

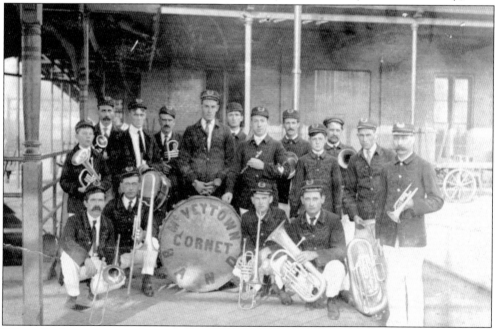

When the famous or near famous came to the railroad station it was obligatory to have a band or bands present. This is the McVeytown Cornet Band at Lewistown Junction. The untitled real-photo postcard shows the members under the roof along the north side of the tracks and probably dates from around 1910. (Courtesy Ernest Solt.)

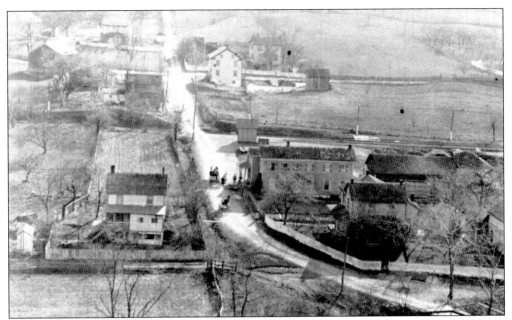

The crossroads are quite visible here at Maitland, as is the rail stop on the Mifflin and Centre Railroad at center. The little village, named for the president of the Pennsylvania Railroad, Thomas J. Maitland, contained a store, post office, school, depot, and several dwellings around 1910. Maitland is about five miles east of Lewistown on Jack's Creek in Derry Township. (Courtesy Ernest Solt.)

Like many other small Mifflin County villages, Mattawana was a stop on the Pennsylvania Railroad. It is located in Bratton Township, just across the Juniata River from McVeytown. The name was spelled Mathawana on a 1767 survey, and it is named for an island in the Juniata River, which means "river of shallows." The Mattawana House offered accommodations along the main line of the railroad. (Courtesy Mifflin County Historical Society.)

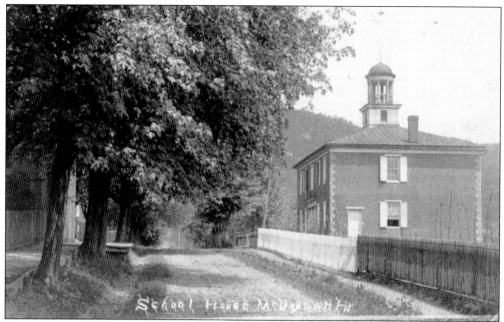

McVeytown Borough was originally called Waynesburg, but in 1833, the community was incorporated as McVeytown, in part to end the confusion with Greene County's Waynesburg. The community began to grow with the arrival of the Pennsylvania Canal. The school, shown above, was completed in 1844 and opened in January 1845. The town's newspaper, the *Village Herald*, described the school, noting, "The New Brick Academy on Queen Street, fronts 52' and is 28' wide, two stories high, and is surmounted by a beautiful cupola." The building still stands today. The town's market square, seen below, looks east toward the Juniata River. It is believed that contractor Ralph Bogle built many of the brick homes in the town. A monument to McVeytown's most famous citizen, Dr. Joseph Trimble Rothrock, who was the father of Pennsylvania forestry, was added to the square in 1924. (Courtesy Ernest Solt.)

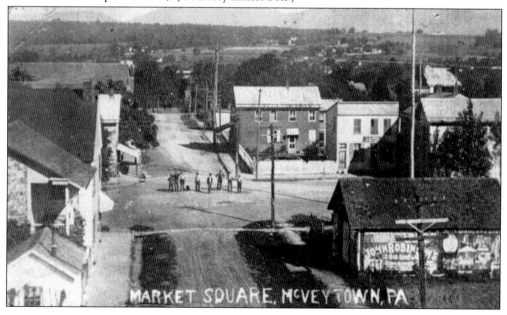

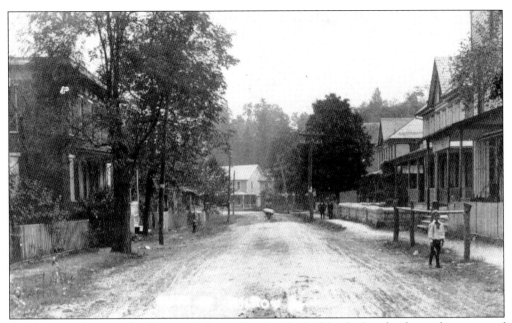

A man is pushing a wheelbarrow laden with what looks like feed sacks down the center of Milroy's Main Street. Considering that the mill was farther down the street, it is a logical assumption. Known as Perryville until 1850, Milroy took its name from Henry Milroy, whose 1766 grant included the land upon which the village sprouted. The photograph dates from about 1910. (Courtesy Ernest Solt.)

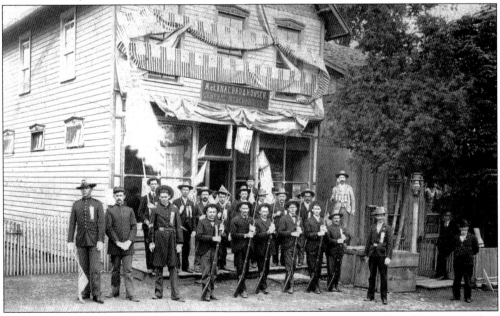

The writing on the back of this historical society photograph notes that these are Milroy lodge men in front of McLanachan and Houser General Merchandise store in the early 1900s. Following the Civil War, there was a surge of fraternal organizations countywide, and this is likely the assemblage of the Milroy Castle No. 275 Knights of the Golden Eagle. (Courtesy Mifflin County Historical Society.)

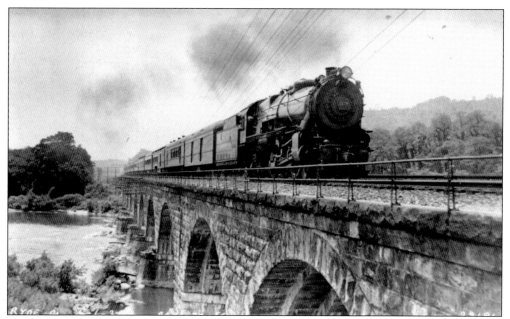

The stone-arched railroad bridge at Ryde crosses the Juniata River as a train travels west on the Pennsylvania Railroad. A century ago, Ryde had a gristmill, store, depot, telegraph office, and a few homes, and it was a station on the main line of the Pennsylvania Railroad. It was originally called Mannayunk or Manayunk, and the post office located there was called Shank's Run. (Courtesy Ernest Solt.)

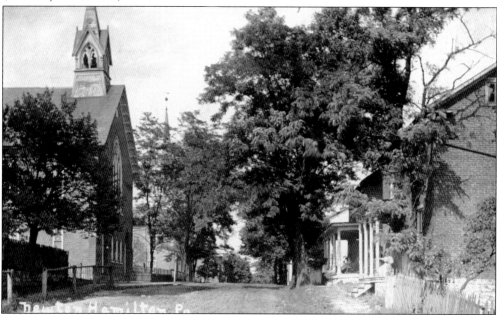

Newton Hamilton became a borough in 1843. A settler named Hugh Brown held a warrant on the land in 1762, but he was killed and his half sisters (with the last name Hamilton) inherited the land. A story asserts that the community was named after the town of Newton Hamilton in County Armagh, Ireland. The Pennsylvania Canal also contributed to the growth of Newton Hamilton. This is Church Street about 1910. (Courtesy Ernest Solt.)

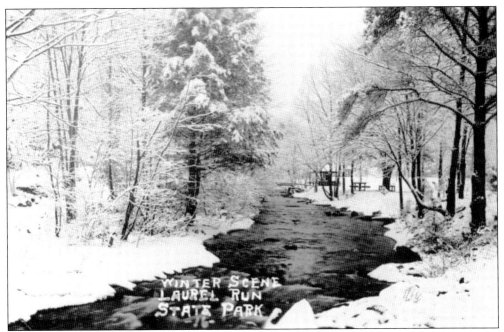

Located in Armagh Township near a small community called Pot Licker Flat (or Pot Liquor Flat to a few) along old U.S. Route 322, was once an area called Laurel Run State Park. This little park had picnic pavilions and offered fishing along the stream. Sunday school picnics and family reunions were held there. The park was covered over by the new U.S. Route 322 and the Laurel Run Reservoir in the early 1970s. (Courtesy Ernest Solt.)

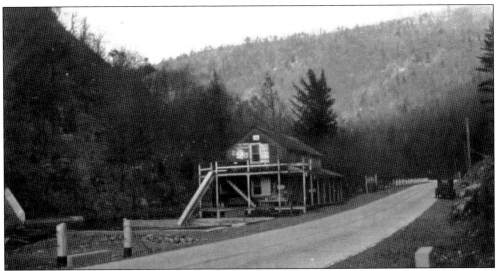

Happy Jim's, a small roadside establishment, is seen here along old U.S. Route 322, which was once the main highway north of Milroy at Pot Licker Flat. The business offered a unique amusement—a swimming pool with a "sliding shoot." The pool was fed by water from Laurel Run, a stream descending through the Seven Mountains and the state park beyond. (Courtesy Ernest Solt.)

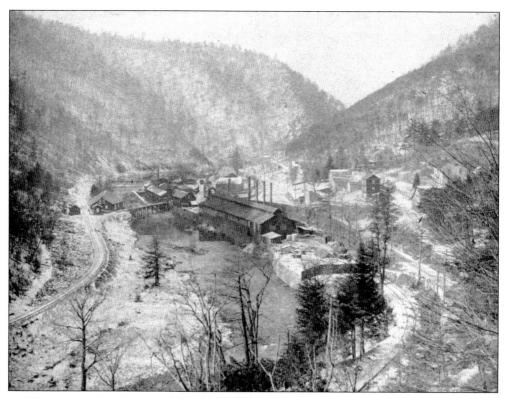

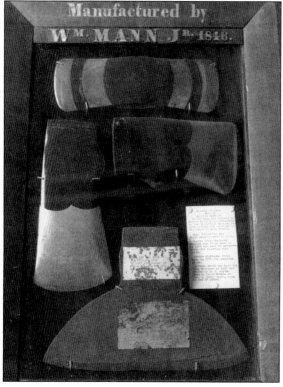

Manufactured by
WM. MANN JR 1846.

William J. Mann Jr. came to Mifflin County in 1835, establishing his axe factory in the Reedsville Narrows, shown above in 1897. At first, he and a helper made about six axes per day in an abandoned stone building. By the late 1880s, the expanding factory's output averaged 1,400 axes per day and employed 200 to 250 workmen. The axe works closed here in the early 1900s. In 1939, the James H. Mann family donated these axes to the historical society. In the photograph at left, the axe at top, a turpentine axe, was first made in 1861. The center left axe is a "Kentucky pattern" made in 1876, while the center right axe was first made in 1870. The broad axe below, made by Mann in 1828, was traded for a new axe in 1885, having been in use for 57 years. (Courtesy Mifflin County Historical Society.)

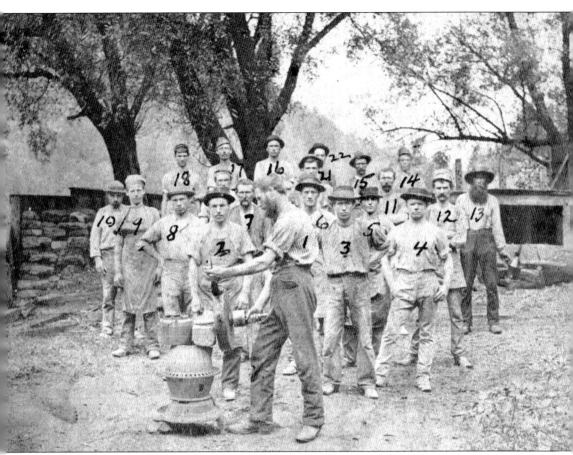

Mann Axe Factory workmen pose in the 1890s. The identification of those pictured was done 50 years ago, numbered on the photograph and identified on the back. By the numbers, the men or things shown are 1. William Tillman Peters (wheel setter), 2. Joseph Wagner, 3. John Wagner, 4. James Fox, 5. Isaac Snook, 6. Robert McCrum, 7. Joseph Snook, 8. ? Peters (wheel polisher), 9. John Peters (wheel polisher, son of William Tillman Peters), 10. Patrick McCormick, 11. Ben F. White, 12. G. V. M. Swab (polisher), 13. David Bell (general utility man), 14. William Fulton, 15. Silas Wertz, 16. Daniel Wertz, 17. George Reynolds, 18. William Smith (axe stocker), 19. not shown, 20. Water tank on Mifflin and Centre Railroad, 21. John Wilson Schaaf, and 22. William O'Hara. (Courtesy Mifflin County Historical Society.)

This 1897 view of Reedsville, located in Brown Township, looks north from Jack's Mountain. In the foreground is a baseball field and train station on the Milroy branch of the Pennsylvania Railroad. The village was first called Brown's Mills after early pioneer William Brown, who was Mifflin County's first judge. Brown had a gristmill and sawmill along Tea Creek in the 1770s. (Courtesy Mifflin County Historical Society.)

Church Hill Cemetery is east of the historic Chief Logan cabin along old U.S. Route 322 at Reedsville. The building in the background was the East Kishacoquillas Presbyterian church that was built in 1858. It was replaced by the present church, constructed in 1892, in Reedsville at the east corner of Walnut and Church Streets. Civil War veteran Gen. John P. Taylor is buried in this cemetery. (Courtesy Mifflin County Historical Society.)

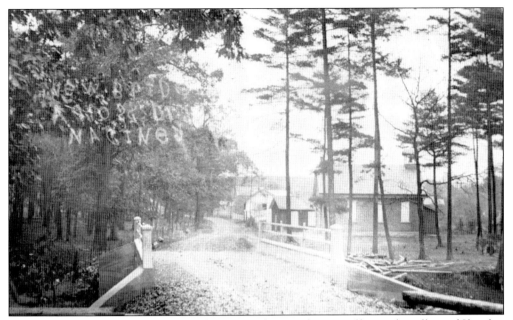

The "Naginey" in this postcard from about 1909 denotes the post office in the village of Shrader, a stop on the Milroy branch of the Pennsylvania Railroad. Named for one of the oldest families in this part of the valley, Shrader was the location of a stone quarry and lime plant. The wooden bridge previous to this one collapsed under the weight of a steam traction engine, killing two people. (Courtesy Ernest Solt.)

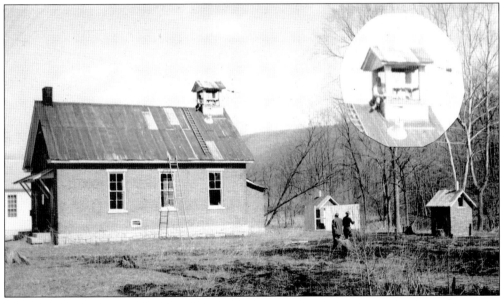

The one-room Shrader School was part of Mifflin County's educational system when every township and borough had multiple school districts. This school was closed in the early 1950s, and students were sent to either Reedsville or Milroy schools. The photograph shows the removal of the school bell shortly after its closure. (Author's collection.)

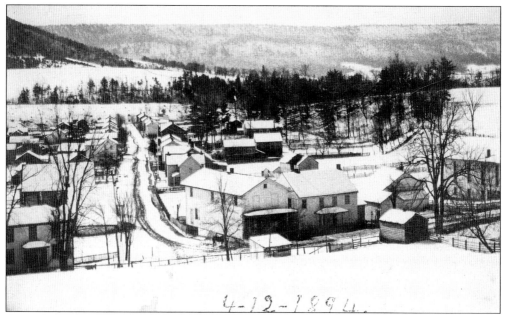

An early spring snowstorm on April 12, 1894, covers the east end of Kishacoquillas Valley and the little village of Siglerville. The main street, looking east, shows wagon tracks bearing to the right in the direction of Milroy. Siglerville was founded in 1847. The first building was a blacksmith shop, constructed by Joseph Sigler, for whom the village was named. (Courtesy Robert L. Aumiller.)

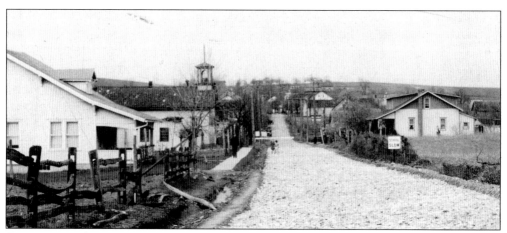

During Pennsylvania governor Gifford Pinchot's second term in the early 1930s, he had a program to "get the farmer out of the mud" by improving the old dirt roads. This is Siglerville's newly crushed stone main street around 1931. (Courtesy Mifflin County Historical Society.)

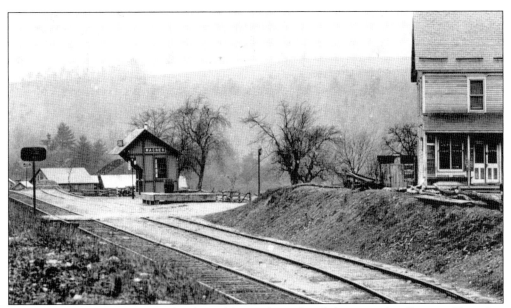

The village name Wagner is plainly visible on the railroad depot in this Decatur Township settlement named for a family living nearby. The hamlet grew up soon after the Sunbury and Lewistown branch of the Pennsylvania Railroad went into operation in 1868. A post office was established there soon after the railroad was completed. (Courtesy Ernest Solt.)

Yeagertown is situated on the west side of Kishacoquillas Creek. It stretches along that creek and the old Lewistown and Kishacoquillas Turnpike (later U.S. Route 322, now Old U.S. Route 322) toward Jack's Mountain for more than a mile. This photograph from about 1910 shows a section of the turnpike. The town derives its name from Jacob Yeager. (Courtesy Mifflin County Historical Society.)

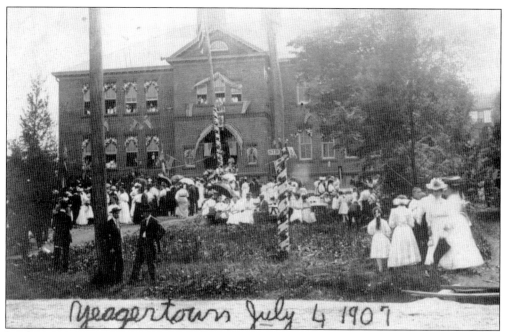

Jacob Yeager came to the place that became Yeagertown from Dauphin County in 1842 with his wife, eight sons, and one daughter. He purchased a mill property and 50 acres of land. On July 4, 1907, the people of Yeagertown gathered at the town's newest school for an Independence Day celebration. The town's first school, a one-room building, was constructed on the same site as the two-story brick building shown above, which was erected in the early 1900s. The photograph below looks toward Main Street in front of the school. Note the electric lightbulbs strung across the school grounds for the entertainment expected to continue after dark. (Courtesy Ernest Solt.)

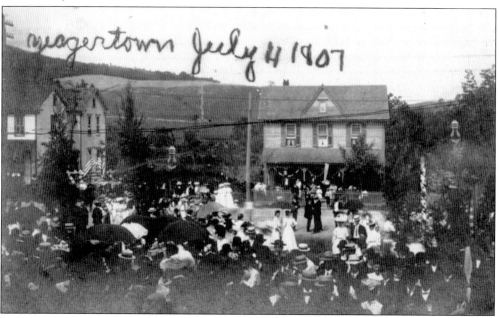

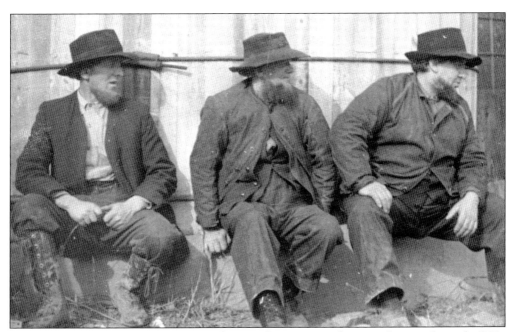

Mifflin County's Amish population can be traced to a group who came here in the early 1790s from southeastern Pennsylvania. The Amish community resides primarily in the Kishacoquillas Valley. This valley exhibits the largest number of cleavages in North America, according to anthropologist and sociologist John A. Hostetler. Five Amish groups and five Mennonite and related groups occupy a valley approximately 30 miles long. The groups are distinguished by the degree to which they have assimilated into the greater society. These differences include the buggies or automobiles driven, forms of dress for both men and women, and worshiping in members' homes or in a meetinghouse or church. These photographs from the 1930s show Amish men at a farm sale and were likely taken by Belleville native A. Franklin Gibboney III. (Above, courtesy Ernest Solt; below, courtesy Mifflin County Historical Society.)

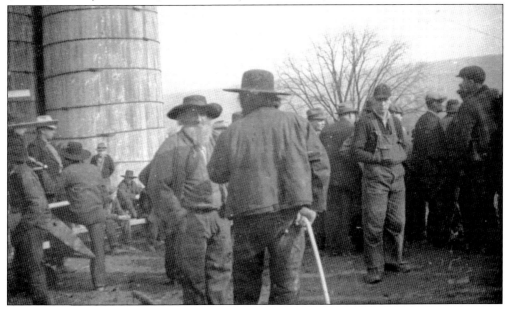

The photograph at left, dated by the Belleville firemen's carnival sign in the window, shows an Amish mother taking her children into a Belleville store in 1938. The Old School Amish can be described as the most conservative and least assimilated into the prevailing culture. White-top buggies commonly denote this group. Taken around 1900, the photograph below shows an Old School Amish girl walking near the Woodland School in Brown Township. Other Amish and related county groups include Byler Amish (yellow-top buggies), Peachy or Renno Amish (all-black buggies), Zook Amish (automobiles), Conservative Mennonites, Allensville Mennonites, and Belleville Mennonites. An important book exploring the Amish experience was written by county native Joseph W. Yoder. His 1940 *Rosanna of the Amish* details his Irish mother's entrance into Amish society in the Kishacoquillas Valley. The book is still in print. (Courtesy Mifflin County Historical Society.)

Four

PLEASANT DIVERSIONS

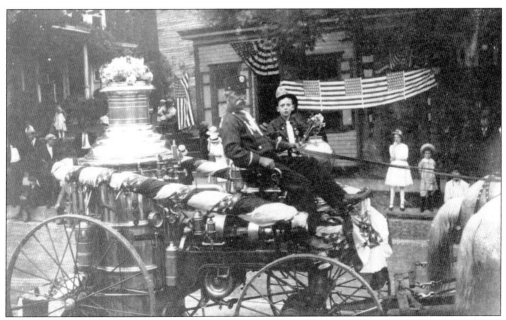

Watching a parade was always a pleasant pastime throughout Mifflin County's many villages and boroughs, whether for patriotic holidays, celebrations, or commemorations. This parade in Lewistown, before World War I, shows the Fame Fire Company's horse-drawn steam pumper decorated for the occasion. However, pastimes were not limited to parades. Hunting, fishing, camping, visiting caves and parks, attending the county fair, or going to the movies were also enjoyed. (Courtesy Ernest Solt.)

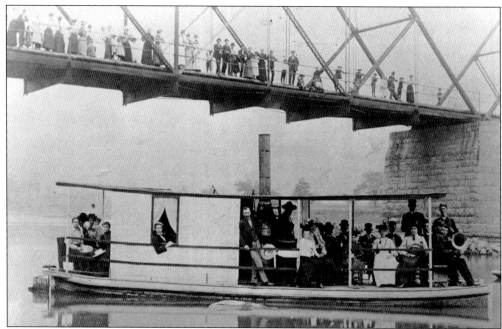

Boating on the Juniata River during the 19th and early 20th centuries was a social occasion. The steamer *Twins* is shown under the bridge at Newton Hamilton. Many forms of water recreation were once popular on the Juniata River. One old engraving, a sort of bird's-eye view of Lewistown from the 1870s, shows sculling on the river. (Courtesy Mifflin County Historical Society.)

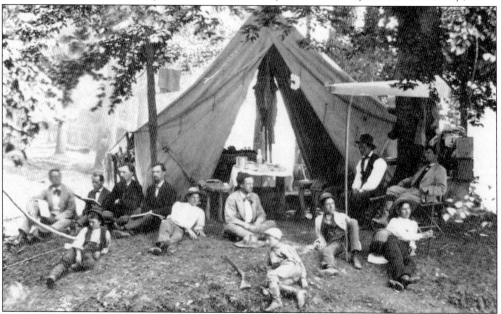

This 1880s camping experience along the Juniata River was above Lewistown and was organized by Rev. W. Maslin Frysinger for friends and family. The group included his brother George Frysinger, who was editor and publisher of the *Lewistown Gazette*. In the 19th century, campers dressed for a social occasion. There was no sportswear in the Victorian age. (Courtesy Mifflin County Historical Society.)

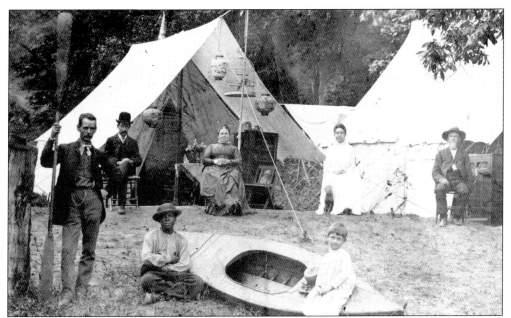

More Victorians along the Juniata River are shown here in the 1890s. This campsite belonged to a Lewistown dentist, Dr. Henry C. Walker. Japanese paper lanterns, a brass birdcage complete with parrot, and even a curio cabinet inside the tent were packed and carted by horse and wagon to the encampment. All the comforts of home were brought along for the duration. (Courtesy Mifflin County Historical Society.)

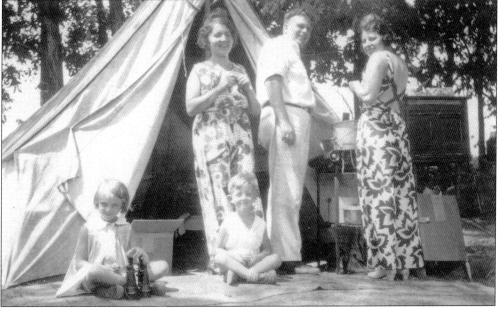

Is this grandmother's camping gear? Another scene along the Juniata River, photographed in the 1930s by Lewistown photographer Luther F. Kepler Sr., illustrates that camping fashions did change. The children, from left to right, are (first row) Iva Anne Kepler and her brother Luther F. Kepler Jr; (second row) Iva Kemrer Kepler, her brother Meade Kemrer, and his wife, Verna Kemrer, at the stove. (Author's collection.)

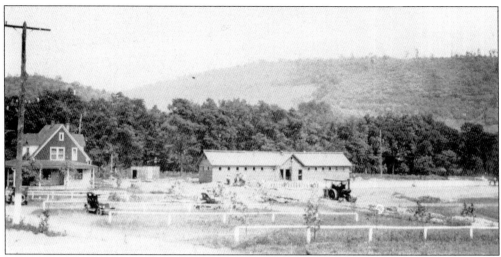

Kishacoquillas Park, named for the nearby creek, was a stop on the trolley line operated by the Lewistown and Reedsville Electric Railway Company. The above photograph shows the construction of the park's pool and bathhouse. Below, the bathhouse can be seen beyond the crowded parking lot. After the trolley line ceased running in 1933, the park eventually added amusements and rides, including a carousel, small roller coaster, bumper cars, and a "fun in the dark" ride. The amusement park closed in the 1970s following the devastation of a flood in 1972, but the swimming pool remained as part of renamed Derry Township Community Park until 1988, when it, too, ceased operation. Today the former Kishacoquillas Park has a well-used walking path and picnic pavilions, as well as camping for recreational vehicles. (Courtesy Mifflin County Historical Society.)

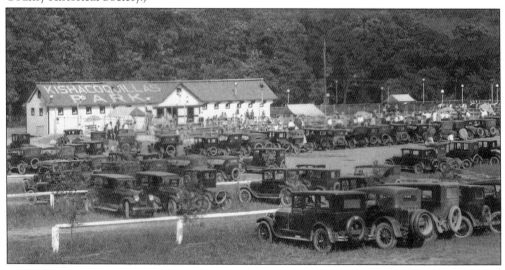

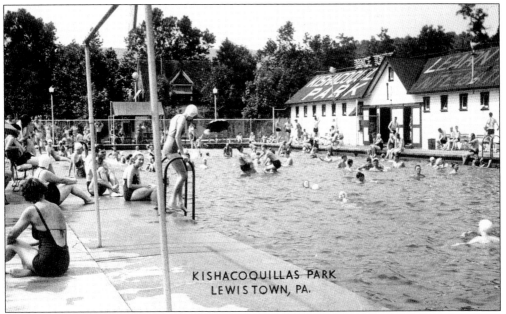

KISHACOQUILLAS PARK
LEWISTOWN, PA.

The Lewistown and Reedsville Electric Railway Company originally had a park at Burnham, called Burnham Park, on an extension line that ran to where Birch Hill is located today. In 1916, the trolley company moved the park to the east (present site of Derry Township Community Park). It became the destination of annual school picnics that arrived by trolley or special trains in the 1930s and eventually by school bus. Students could spend the day picnicking and enjoying the amusement rides. The swimming pool was a popular pastime, too. Family reunions and company picnics also occurred at the park. The cafeteria pavilion, at the park's center, was a perfect stop to gather the family or for a group photograph. (Courtesy Mifflin County Historical Society.)

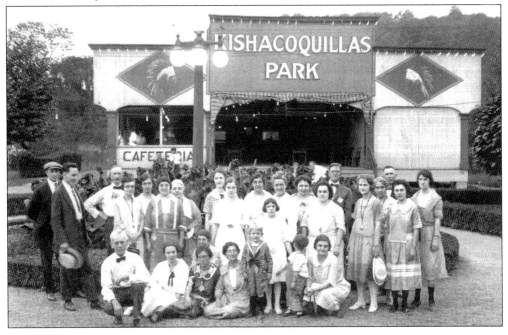

SEAWRA CAVE, Lewistown, Pa.

Visiting commercial caves was a popular pastime during the first few decades of the 20th century. Two boys discovered a cave on the property of C. P. Wray. A partnership with the Searer brothers brought about the opening of Seawra Cave in 1928. The cave is 12 miles northeast of Lewistown and four miles from Alfarata on a low ridge parallel to Jack's Mountain. The 615 feet of dry cave were opened to the public in a nearly straight passage and were no more than a few yards wide at any one place. A contemporary source observed that a nice variety of stalactites and stalagmites were abundant. From a wooden walkway, visitors could glimpse passages and rooms about 50 to 75 feet below. However, Seawra's somewhat remote location deterred visitors, resulting in closure 10 years later. (Above, author's collection; left, courtesy Ernest Solt.)

Advertised as the "Carlsbad of Pennsylvania," Alexander Caverns lured tourists to the area during its commercial operation, from 1929 to 1954. Alexander Caverns is located nine miles northeast of Lewistown and three and one half miles from Reedsville. It was one of a special group of attractions that are today termed as "show caves," or spectacular natural wonders that draw in the tourists. The tour once included a dry cave and a boat tour of the wet section. The Newcomers Club of Mifflin County toured the underground attraction in 1950. The Alexander family, led by Reed Maclay (Mac) Alexander, operated the cave originally, while in 1940, area businessman Luther F. Kepler Sr. took over the commercial lease until it expired in 1954. An underground stream emerges from the mouth of the cave, serving as the source of Honey Creek. (Author's collection.)

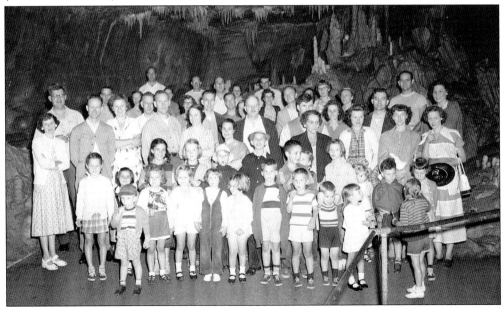

The barker announced the evening show in front of the main grandstand at the Mifflin County Fair in the 1930s. Admission was just 50¢. There were homegrown vegetables, baked goods, and home canned fruits on exhibit, as well as the judging of sheep and cattle. Every night at 11:00 p.m. was the much anticipated fireworks display. Local children looked forward to the annual event too. Complimentary tickets allowed children admission to the rides for just 5¢ on Kid's Day. Occasionally someone would squeeze in without paying admission or perhaps get a bit rowdy, so the fair organizers maintained uniformed guards to patrol the grounds. Fresh-squeezed orange juice, cotton candy, and peppermint sticks were some of the available treats. A popular refreshment stand was the Hires Root Beer concession. (Author's collection.)

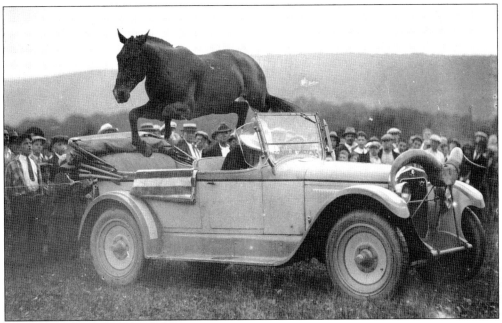

Attractions, including car, motorcycle, and horse racing, professional acrobats, and novelty acts awed the crowds each year at the Mifflin County Fair. California Frank Rodeo Attractions performed prior to the show around 1930. The fair was held on grounds now occupied by Lewistown Area High School. The weeklong event also brought Lucky Teter's Hell Drivers to the fairgrounds in 1936, headlined by premier stunt driver Earl "Lucky" Teter. Thousands came to see the driving daredevils crash through burning walls, jump cars, or run a car on two wheels. Teter is shown here with Lewistown's official greeter, pharmacist Edwin S. Eby. Known as "Doc" Eby to everyone, he was renowned for his health drink, Wisto, a name composed of the five central letters in the name Lewistown. Celebrities stopped at Eby's drugstore for the elixir. (Author's collection.)

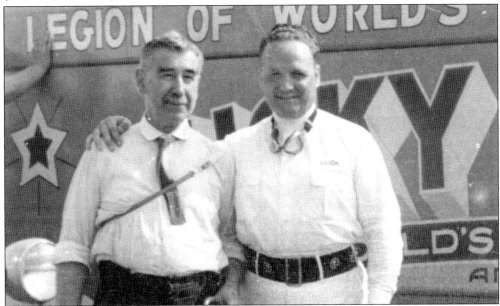

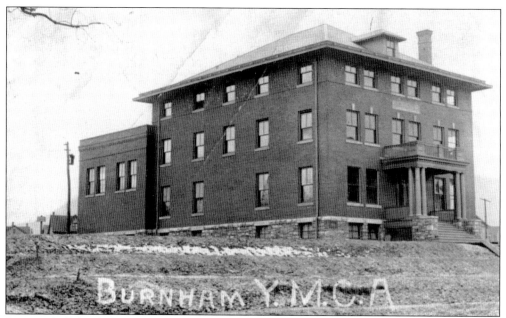

Sports of all kinds have been popular in Mifflin County. Baseball, football, and basketball have always been favorites. Other competitive sports mentioned in historical accounts include croquet, ox racing, marbles, boat racing, boxing, and fast walking. The YMCA offered sporting activities locally as early as 1863 when annual memberships were 50¢. The Burnham YMCA was built in 1908 and added a swimming pool in 1912. (Courtesy Ernest Solt.)

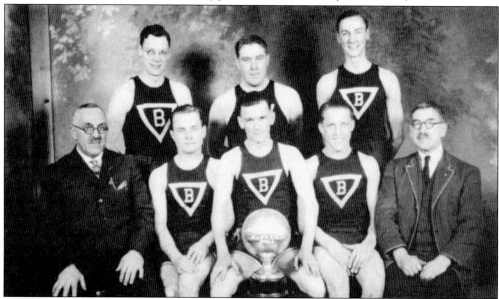

The Burnham YMCA state basketball championship team is shown here. They defeated YMCA teams from Philadelphia, York, Lancaster, and Williamsport to clinch the title. Pictured, from left to right, are (first row) Prof. J. S. Kohler, Charles Wilson, Dalle Wilson, Howard Feese, and Edwin S. "Doc" Eby; (second row) Raymond Kohler, Earnest McCurry, and Harry Wike. Ralph Shawver was not present. It is not known if the boys drank Wisto. (Courtesy Mifflin County Historical Society.)

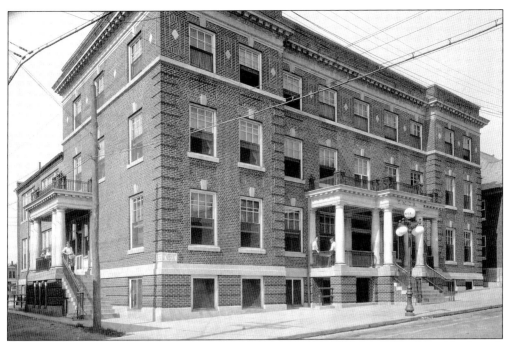

On July 16, 1920, the Lewistown YMCA on North Dorcas Street was opened to the public. It took a total of $250,000 to complete the building, which provided a safe place for young men and boys to enjoy recreation. Tours of the new building were conducted during the opening, culminating with a banquet in the facility. Offering pool and other athletic activities in the confines of the YMCA building, it also provided a safe place to play away from unwanted influences. Furthering that goal, Rev. Reid S. Dickson donated an athletic field to the YMCA in 1920, and the field was named Dickson Field in his honor. The building was torn down during the redevelopment era of downtown Lewistown in the late 1960s. (Author's collection.)

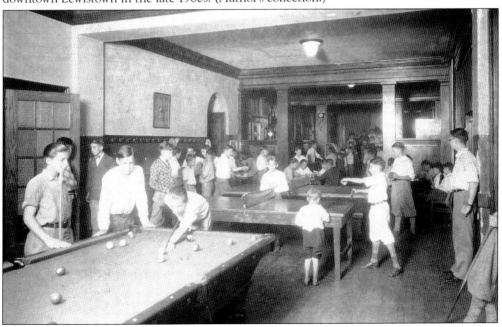

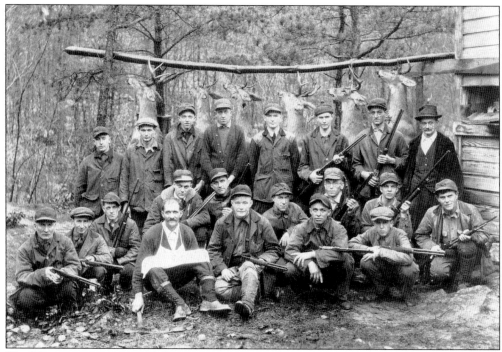

The Moravian missionary of the Colonial period John Heckewelder noted that the American Indian people living in the Juniata River area considered this territory prime hunting ground for deer, beaver, and elk. An unnamed group of hunters enjoyed a successful hunt in northeastern Mifflin County, according to identification on the back of this 1920s photograph. Deer hunting was then, and remains, a traditional late fall pastime. (Courtesy Mifflin County Historical Society.)

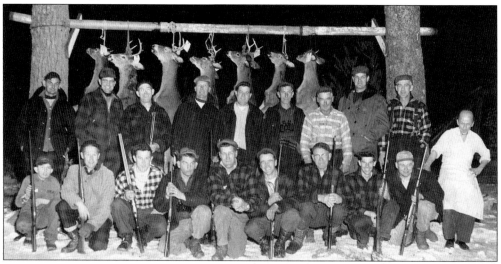

Seven antlered deer were shot before noon near Short Drive Camp in Milroy in 1958. Hunters shown, from left to right, are (first row) Bobby Dean Keller, Warren Yetter, Charles Armstrong, Robert Goss, Henry Fisher, John Glick, George Grove, John Davies, and Robert Irwin; (second row) Bobby Johnson, Bob Keller, Ray Kauffman Sr., Kyle Fisher, Harry Taylor, Bob Schmitel, Harry Armstrong, Ross Fisher, and Paul Armstrong. (Author's collection.)

Luther F. Kepler Sr. and Iva Kemrer Kepler wear the latest angling gear in these vintage 1925 photographs. The Keplers fished throughout Mifflin and Juniata Counties at that time, enjoying a pastime still pursued by many fishing enthusiasts. Mifflin County offers a number of very popular trout streams, including Havice and Treaster Runs, Honey Creek, East Licking Creek, Kishacoquillas Creek, and Tea Creek. In 1922, a trout measuring over 25 inches was caught in Honey Creek, a national record that year. Luther recounted stories of fishing the Juniata River for shad and eels as a young boy about 1910. Historically, according to the Chesapeake Bay Foundation, the Juniata River's shad population may have been as large as 200,000 fish per year at that time. Fishing remains a popular Mifflin County pastime. (Author's collection.)

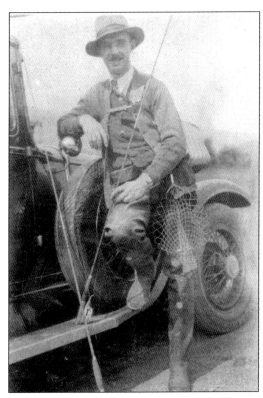

Lewistown had five movie theaters in 1951, including the Embassy, Miller, Pastime, Rialto (shown around 1940), and Temple. All are now closed except the Miller, which operates as a multiplex today. Many other operations opened and closed over the years, including the Orphium, the Temple Opera House, Smith's Rink Theatre, the Nickledom, and the Grand Theatre. The Embassy Theatre on South Main Street still stands as an excellent surviving example of theater architecture from the 1920s. Built in 1927, the motion picture and vaudeville theater is on the National Register of Historic Places. These are the original ushers who sat for a photograph in February 1928. From left to right, are (seated) Charles Sims, Harold Bittinger, and Charles Hackenberry; (standing) Francis Stumpf, Tommy Tomlinson, Lawrence Jaraskie, and George Barnes. Friends of the Embassy are restoring the historic theater. (Author's collection.)

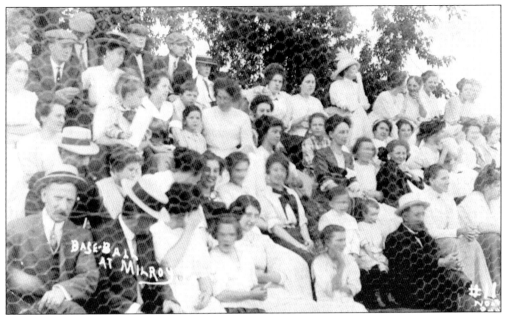

Spectators shown here enjoy the ball game at Milroy in the early 1900s. Baseball has been popular in Mifflin County for both players and spectators alike for over 140 years. The first game in Mifflin County mentioned historically occurred in 1866 and ended with a score of 103-78. Towns had their own teams, like the Allensville Never Sweats, Siglerville Left Hand Club, and Lewistown's Sluggers. (Courtesy Ernest Solt.)

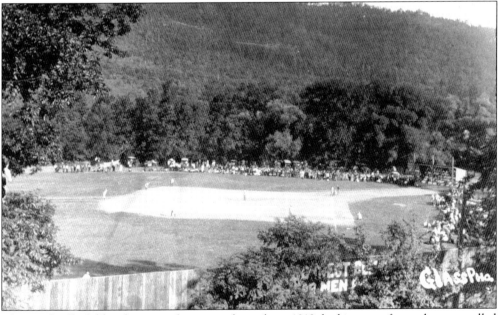

The Reedsville field is shown in this image from about 1910, looking east from what was called the "cow hill." An earlier baseball field was west of the old railroad station. The Reedsville team of the early 1900s beat all comers to become county champions for years running. Family names associated with Reedsville baseball then included Kelley, McCartney, McDonald, Rice, and Walker. The Rice brothers were professional-caliber players. (Courtesy Ernest Solt.)

Parades have been a part of Mifflin County's pastimes for generations. The 1938 Rayon Parade celebrated the multiple uses of unique man-made fabrics of the American Viscose Corporation. This event involved floats from the county's many communities, most of which had citizens employed by the American Viscose Corporation, one of Mifflin County's largest employers at the time. High school and community bands were always part of such events. Firemen's processions and commemorative parades have continued to this day, as typified by the 1910 Fourth of July parade on the main street of Belleville. The Yeagertown Band, like the other community bands, performed throughout the county. Parades on Veterans Day, Memorial Day, or during community anniversary events are still enjoyed by the whole county. (Courtesy Mifflin County Historical Society.)

Five

TRAGIC EVENTS

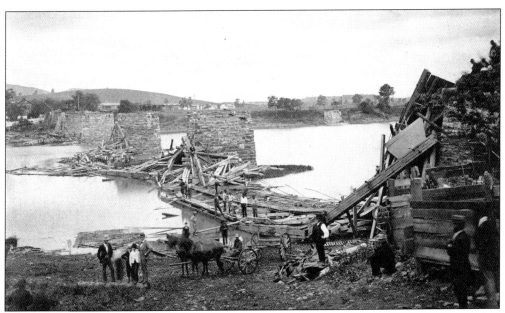

These events come out of a clear blue sky, perhaps without warning. It might affect an individual or two, a community, or the entire county. An example is the tornado of 1874 that descended from the sky on the Fourth of July, demolishing buildings and this covered bridge across the Juniata River at Lewistown, killing or injuring those who took shelter within. What follows are some tragic events, natural or man-made, that touched Mifflin County. (Courtesy Mifflin County Historical Society.)

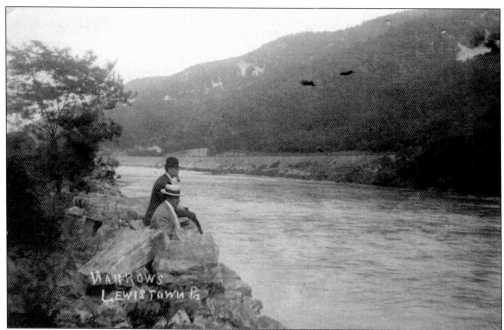

These photographs show the location where, on the night of August 31, 1909, the *Pittsburgh Express* was stopped at 2:00 a.m. by blasts of nitroglycerin. A bandit appeared by the stopped train wearing a sack over his head with two eyeholes burned in it and a revolver in each hand. He wounded a railroad employee. Quickly filling a sack with bags of coins in the express car, the bandit disappeared into the dense wooded surroundings of the Long Narrows. He stashed the heavy bags of would-be gold in the woods, but instead of $10 gold pieces, he had newly minted, first-ever Lincoln pennies. He left the loot scattered among the leaves and was never apprehended. Some 50 years later, three hunters found almost 4,000 of the 1909 pennies in the woods near the robbery site. (Courtesy Ernest Solt.)

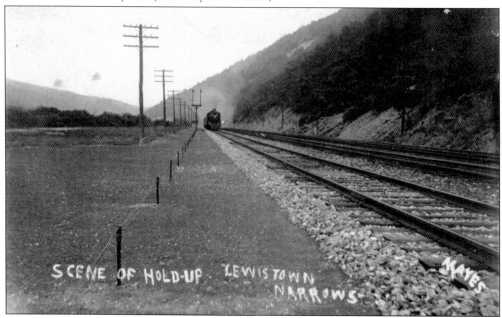

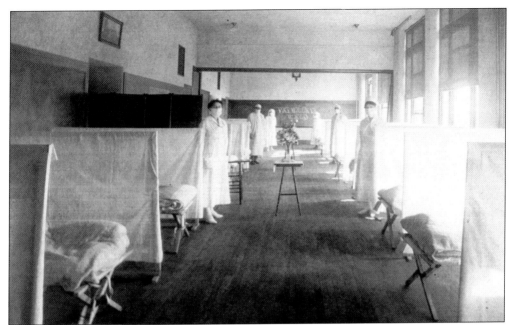

The influenza pandemic of 1918 struck suddenly. A friend or relative who was perfectly healthy one day was dead the next. All amusement places throughout Mifflin County were closed in October of that year in response. Ordinances about spitting in the streets were considered or enacted, and people wore surgical-type masks. Local officials closed churches and schools. The Lewistown Hospital was so beleaguered by the number of patients that Lewistown High School was commandeered and used as an emergency medical facility. That year, children skipped rope to the rhyme, "I had a little bird, Its name was Enza. I opened the window, And in-flu-enza." At the height of the epidemic locally, 22 persons died in a 24-hour period. By the end of October, 214 deaths were attributed to the disease. (Courtesy Mifflin County Historical Society.)

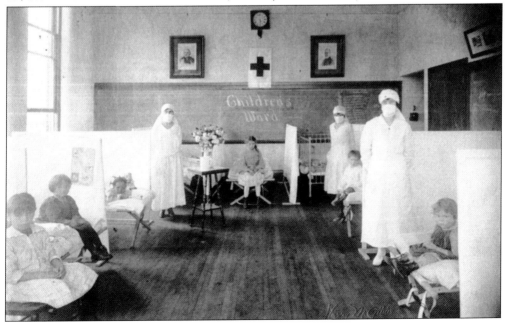

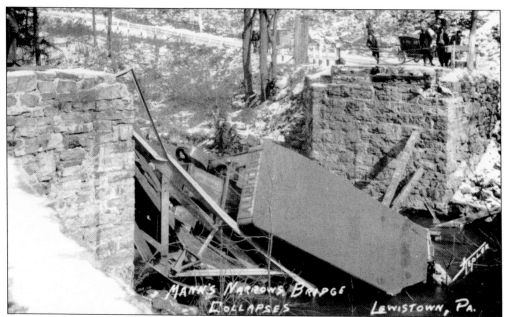

On March 2, 1929, the wooden bridge over Kishacoquillas Creek in Mann's Narrows, also called the Reedsville Narrows, collapsed under the weight of a moving van belonging to the Security Storage and Carpet Cleaning Company of Philadelphia. Driver Arthur Pryor was not seriously hurt but was placed under arrest for reckless driving and failing to have a valid 1925 driver's license. (Courtesy Ernest Solt.)

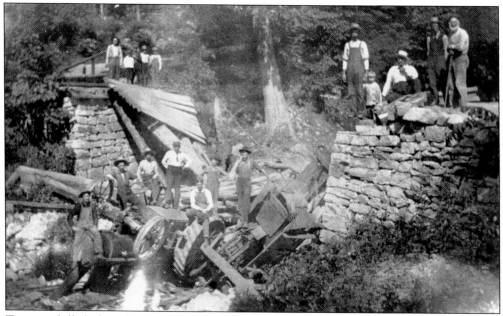

Two were killed when the steam traction engine and thrasher proved too heavy for the Shrader Bridge on July 19, 1908. The place was also known by its post office, called Naginey. A group of farmworkers from Reed Maclay (Mac) Alexander's farm were within sight of home when the accident happened. William Close and Willis Alexander died as the result of terrible injuries. (Courtesy Ernest Solt.)

Frank Lee arrived in Mifflin County in 1903. The 30 year old was one of 14 children in his family born in Virginia. Lee moved north to find work and employment as a laborer at Standard Steel Works in 1908. That same year, he entered into a partnership with George Porter, who operated a small store on the square. On the night of November 26, 1908, Lee came to Porter's store to settle their weekly accounts. An argument ensued, blows were struck, and Lee left but came back with a shotgun. He entered the store and fatally shot Porter in the chest. Lee fled and eventually reached his former Virginia home. He was returned in January 1909, tried, and convicted of Porter's murder. After a retrial granted on technical grounds, Lee was again found guilty and was hanged on this scaffold (on loan from Dauphin County) in the courtyard of the county jail, shown here, on May 11, 1911. He was the only man ever executed in Mifflin County. (Courtesy James R. Fosselman.)

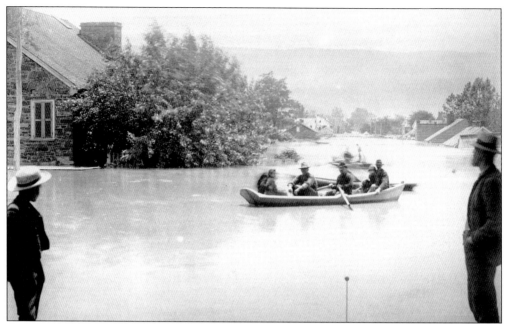

One of the record floods in the history of Mifflin County occurred in 1889, the same year as the great Johnstown flood. The Juniata River rose 50 feet above the low water mark, touching the alley below the National Hotel. This image looks east down South Main Street in Lewistown after some receding had occurred. In the end, 150 houses were carried away or damaged. (Courtesy Mifflin County Historical Society.)

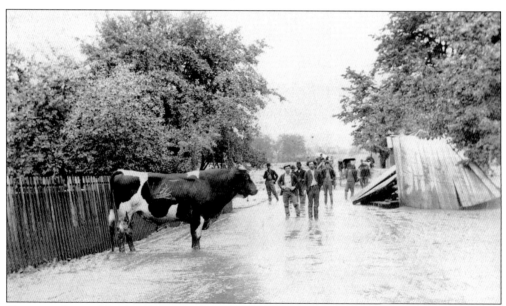

He was a thoroughbred, a famous bull, and a survivor. James Shannon's prized bull was swept from his barn in rising waters, found footing among the drift of the crumbled barn, and rode downstream to the railroad bridge. The bridge gave way and spectators feared the worst, but he found purchase on a cinder pile, and stood there stoically until the waters receded. (Courtesy Mifflin County Historical Society.)

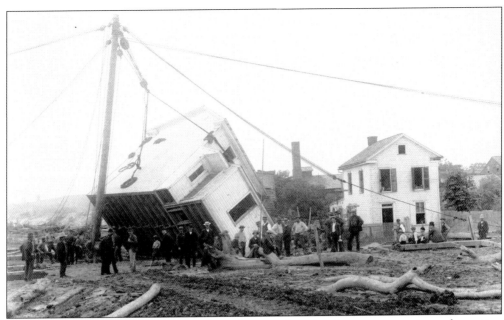

One account notes that after 1889, local people stopped putting dates on events; instead counting something as "before the flood" or "after the flood." Everything imaginable came floating down the terrible torrent. A haystack bobbed downstream with a flock of feeding chickens atop the mound, oblivious to the calamity. Water came to within 200 feet of Lewistown's square. Rebuilding took years. (Courtesy Mifflin County Historical Society.)

Mr. and Mrs. Joseph Riden and their dog were caught in their home the night floodwaters rose, lifting their house from its foundation. The trio clambered to the roof, terrified, and rode almost 10 miles downstream until they were rescued just before the house disintegrated. The couple sold copies of this photograph after the harrowing adventure, to help raise money to offset their loss. (Courtesy Mifflin County Historical Society.)

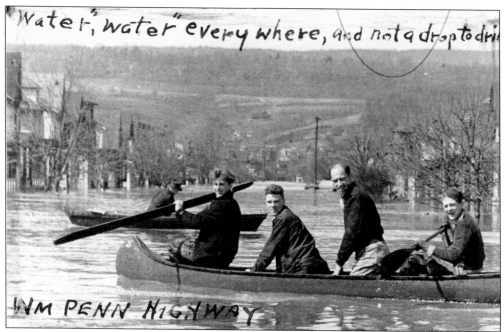

"Water, water" every where, and not a drop to dri[nk]

WM PENN HIGHWAY

The St. Patrick's Day flood in 1936 sent waters rising through the Juniata Valley. This flood crested at 43.5 feet compared to the 50 feet of the 1889 catastrophe, but the south end of Lewistown was a disaster nonetheless, as shown here. In total, 800 residences were damaged or destroyed. Three men drowned at Granville. (Courtesy Ernest Solt.)

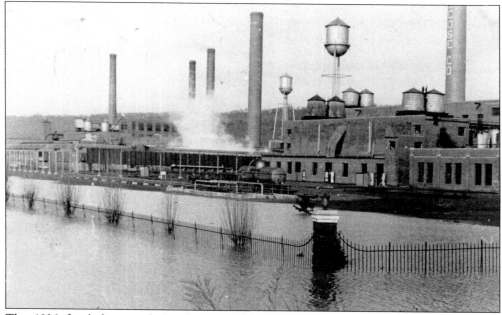

The 1936 flood devastated the American Viscose Company plant across the river from Lewistown. With total flood damage for Mifflin County set at $4 million, disaster costs at the plant alone were set at $2 million. The plant cleaned up and reopened. However, with the 1972 flood, cresting in Lewistown at 42.1 feet, and with area damage assessed at $144 million, the plant had to close permanently. (Courtesy Ernest Solt.)

Six

NOTEWORTHY
INDIVIDUALS

Earle W. F. Childs (1893–1918) was born in Philadelphia, and his family came to Mifflin County to operate a wholesale food company. Childs was the youngest commissioned U.S. Naval Academy graduate at the time in 1915, believed to be first in service from Lewistown during World War I, and the first U.S. Navy officer to die in a submarine. On board the British submarine HMS *H5* as an observer, the lieutenant was lost when the submarine sank after a collision off the Welsh coast. (Courtesy Mifflin County Historical Society.)

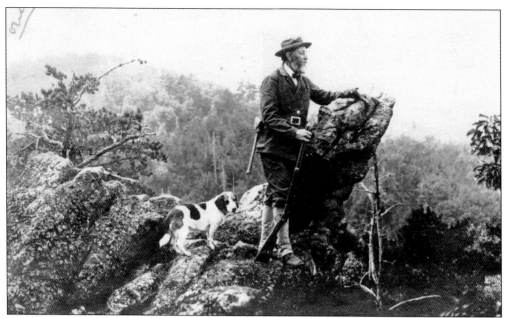

Joseph Trimble Rothrock (1839–1922) was born on April 9, 1839, in McVeytown. He died at age 83 on June 2, 1922, in West Chester. A Civil War veteran and medical doctor, Rothrock is remembered as the father of Pennsylvania forestry. His interest in forestry developed when he walked across the mountains from McVeytown to Tuscarora Academy in Juniata County. (Courtesy Mifflin County Historical Society.)

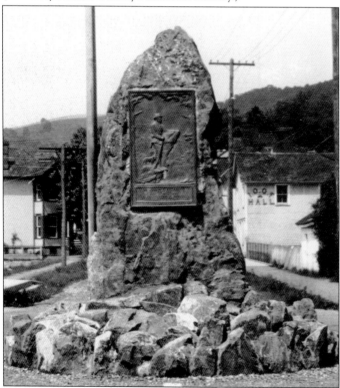

This plaque, on a native mountain boulder in McVeytown's square, commemorates Rothrock's place of birth. The boulder was unveiled and dedicated on November 1, 1924, pursuant to an act of the Pennsylvania legislature to establish a memorial to Rothrock's memory. The image on the plaque shows Rothrock and his dog, Rab (short for rabbit), in a familiar pose in the state forests he loved. (Courtesy Mifflin County Historical Society.)

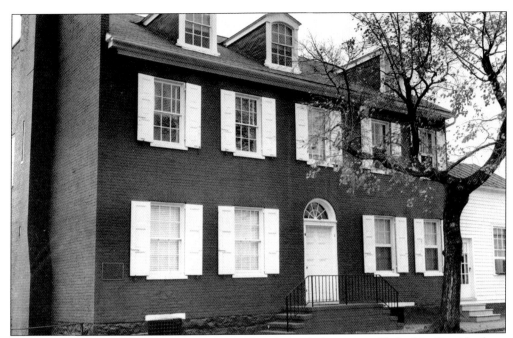

This brick building in McVeytown is the Rothrock family home, established by Dr. Abraham Rothrock, first president of the Mifflin County Medical Society. In 1956, the county medical society and the Medical Society of Pennsylvania unveiled a plaque recognizing the home as the birthplace of Joseph Trimble Rothrock. (Courtesy Mifflin County Historical Society.)

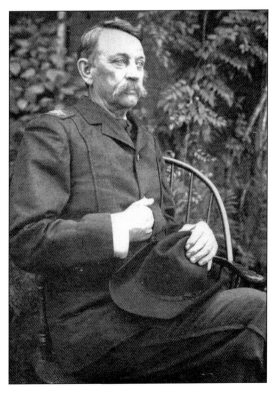

In 1895, Rothrock became the first commissioner of the Pennsylvania Bureau of Forestry. He established technical forestry training for foresters, which he personally supervised. He frequently toured the training areas on his favorite horse, Pet. He is shown in the department's training school uniform. During his term, the state forests were established, protecting thousands of acres of Pennsylvania woodlands. Rothrock State Forest is named in his honor. (Courtesy Mifflin County Historical Society.)

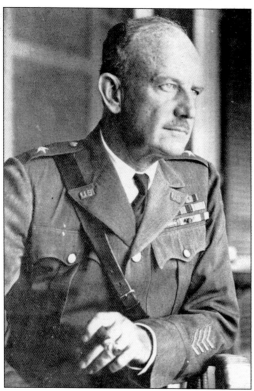

Maj. Gen. Frank Ross McCoy (1874–1954) had a distinguished career as a U.S. soldier and diplomat. He was born at 17 North Main Street in Lewistown on October 29, 1874, attended Mifflin County schools, and graduated from West Point as second in the class of 1897. He served seven U.S. presidents during his military and diplomatic career. (Courtesy Mifflin County Historical Society.)

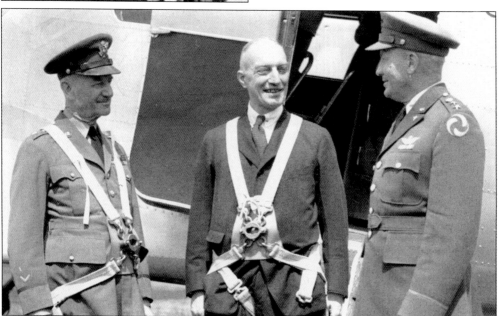

McCoy served in military and diplomatic positions from 1898 through 1938 in Europe, the Philippines, Nicaragua, and South America. In 1936, he was sent to Governor's Island, New York, commanding the first army. Shown here, from left to right, are McCoy, *New York Herald Tribune* owner and publisher Ogden Reid, and Army Air Force general Frank M. Andrews. (Courtesy Mifflin County Historical Society.)

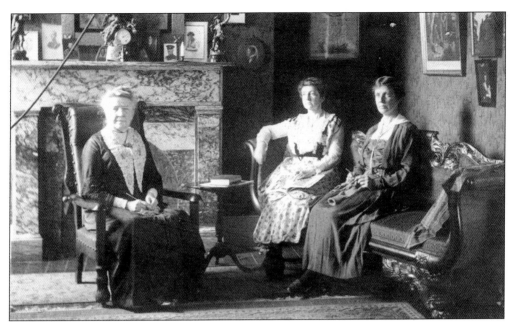

McCoy's father, Thomas, served as a general in the Mexican-American War and the Civil War. His mother and sisters lived at the family home in Lewistown after his father died. Sitting in the parlor at 17 North Main Street, from left to right, are his mother, Margaret, and sisters Margaretta and Hannah McCoy. McCoy returned to Lewistown with his wife, Frances Judson McCoy, upon his retirement in 1938. (Courtesy Mifflin County Historical Society.)

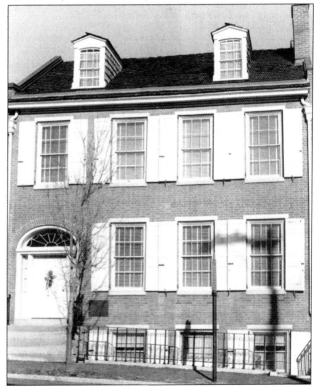

McCoy had a short retirement when World War II brought him back to government service. He served on the 1941 Pearl Harbor investigation, was appointed president of the military commission trying Nazi saboteurs, and chaired the Far East commission in 1945. McCoy's home is on the National Register of Historic Places and is now the Mifflin County Historical Society's museum. (Courtesy Mifflin County Historical Society.)

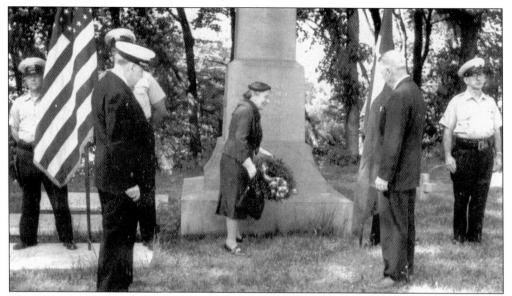

Mifflin County had three men killed in 1836 defending the Alamo during the Texas struggle for independence from Mexico. David Cummings Porter, John Purdy Reynolds, and William McDowell were native sons who journeyed to Texas with notable Americans such as Davy Crockett. Hannah McCoy, for the Mifflin County Historical Society, places a wreath at the Reynolds memorial at St. Mark's Cemetery in Lewistown in 1962. (Courtesy Mifflin County Historical Society.)

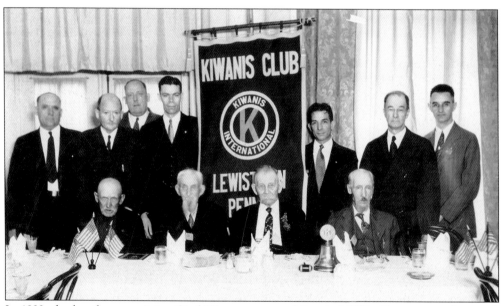

In 1933, the last four remaining Civil War veterans residing in Mifflin County were honored. These men, from left to right, are (seated) David C. Brubaker of Lewistown, Edward Stumpf of Belleville, Newton C. Harmon of Lewistown, and William Hall of Lewistown. The Kiwanis members, from left to right, are (standing) H. H. Leopold, unidentified, unidentified, Paul S. Lehman, Ralph Barchus, Judge William W. Uttley (guest and son of a veteran), and J. Martin Stroup. (Courtesy Mifflin County Historical Society.)

Harmon (1849–1936) was the last surviving Civil War veteran living in Mifflin County. He served as a private who was mustered into service on February 9, 1864. He transferred to the 119th Regiment, Pennsylvania Volunteers on May 31, 1864. His regiment lost nine officers, and 132 enlisted men were mortally wounded. Harmon was 90 years old at the time of his death. (Courtesy Mifflin County Historical Society.)

Four Mifflin County veterans received the Congressional Medal of Honor for valor, bravery, and gallantry, including John Andrew Davidsizer, James Parker Landis, John Lilley, and William H. Rankin, who saw service in the Civil War. Davidsizer, Landis, and Lilley received medals for Civil War service, while Rankin's medal came during action against hostile American Indians in 1872. Rankin's grave (seen at far right) is in St. Mark's Cemetery in Lewistown. (Courtesy Mifflin County Historical Society.)

The Mifflin County Historical Society formally incorporated in 1921 to preserve the county's past for the generations yet to come. The charter members, from left to right, are (seated) H. H. Laub Jr., Frank E. Mann, George R. Frysinger, Ben Ruble, and George F. Stackpole; (standing) Isabelle Shimp, D. Banks Moist, Lawrence D. Ruble, William A. Burlew, and Mary C. Slagle. (Courtesy Mifflin County Historical Society.)

John P. Taylor (1827–1914) was one of Mifflin County's best known and most easily recognized citizens. Born in Reedsville, Taylor was a Civil War veteran who received the brevet rank of brigadier general. He was president of the Pennsylvania Monument Commission that regulated the memorials at Gettysburg. Following his death, he was interred in a coffin made from a recast bronze cannon. (Courtesy Mifflin County Historical Society.)

Frank H. Wentz (1834–1917) was post adjutant at Fort Mifflin near Philadelphia during the Civil War. After the war, Wentz became a local manufacturer of soft drinks and became known in later years as the "Pop Man." Wentz became active in Lewistown's Henderson Volunteer Fire Company and was elected chief engineer in 1878. He served in that capacity until a few years prior to his death. (Courtesy Mifflin County Historical Society.)

Eleanor M. Aurand, M.D. (1923–2004) was the first and only native-born Mifflin County woman to go away to study medicine and return home to practice. She was also the first pediatrician in Mifflin and Juniata Counties. From 1962 to 1981, Aurand was the only pediatrician in Mifflin County. (Author's collection.)

BIBLIOGRAPHY

Atlas of Perry, Juniata and Mifflin Counties, Pennsylvania. Philadelphia: Pomeroy, Whitman and Company, 1877.

Copeland, Willis R. *The Logan Guards of Lewistown, Pennsylvania Our First Defenders of 1861*. Lewistown, PA: Mifflin County Historical Society, 1962.

Bowen, Eli. *Sketch-Book of Pennsylvania Or Its Scenery, Internal Improvements, Resources, and Agriculture*. Philadelphia: Willis P. Hazaard, 1852.

Ellis, Franklin. *History of that part of the Susquehanna and Juniata Valleys, Embraced in the Counties of Mifflin, Juniata, Perry, Union and Snyder in the Commonwealth of Pennsylvania*. Philadelphia: Everts, Peck and Richard, 1886.

Elliott, Richard Smith. *Notes Taken in Sixty Years*. St. Louis: R. P. Studley and Company, Printers, 1883.

Fosnot, H. J. *Lewistown, Penna., As It Is*. Lewistown, PA: Lewistown *Gazette*, 1894.

Hunter, William A. *Forts on the Pennsylvania Frontier, 1753–1758*. Harrisburg, PA: Pennsylvania Historical and Museum Commission, 1960.

Kauffman, S. Daune. *Mifflin County Amish and Mennonite Story 1791–1991*. Belleville, PA: Mifflin County Mennonite Historical Society, 1991.

Mifflin County Historical Society. *Two Hundred Years - A Chronological List of Events in the History of Mifflin County, Pennsylvania 1752–1957*. Lewistown, PA: Mifflin County Historical Society, 1957.

Sentinel Company. *Historical Souvenir of Lewistown, Penna*. Lewistown, PA: The Sentinel Company and Old Home Week Celebration Committee, 1925.

Sentinel. "Climb Aboard! Celebrate Historic Mifflin County." Lewistown, PA: The Sentinel Company, 1989.

Shively, R. H., ed. *Commemorative Biographical Encyclopedia of the Juniata Valley, comprising the Counties of Huntingdon, Mifflin, Juniata and Perry, Pennsylvania*. Chambersburg, PA: J. M. Runk and Company, 1897.

Stroup, J. M. and R. M. Bell. *The Genesis of Mifflin County Pennsylvania*. Lewistown, PA: Mifflin County Historical Society, 1958.

Wagner, Orren R. *The Main Line of the Pennsylvania Canal through Mifflin County*. Lewistown, PA: Mifflin County Historical Society, 1963.

INDEX

Alamo, 8, 122
Alexander Caverns, 99
Amish, 91, 92
Aurand, Eleanor M., M.D., 125
Buchanan, Dorcas Holt, 7, 8, 12
Childs, Earle W. F., 117
Congressional Medal of Honor, 8, 123
Dipple pottery, 64
Drayer, Peter, 45
Dyer, W. C., 44
Elliott, Richard Smith, 37
Elliott, William P., 37
first airmail delivery, 67
flood of 1889, 114, 115
flood of 1936, 116
Fort Granville, 13–17
Harmon, Newton C., 122, 123
influenza pandemic of 1918, 111
Kepler Sr., Luther, F., 39, 95, 99, 105
Kepler, James A., 39
Kishacoquillas Park, 96
Lewis, William, 26
Logan, Mingo chief, 18, 19
Malta Home, 75
Mann Axe Factory, 85
Mann, William J., Jr., 84
McCoy, Frank Ross, 120, 121
Mifflin County Fair, 100, 101
Mifflin County Historical Society charter members, 124
Mifflin, Thomas, 20
Moller car, 65, 66
Pennsylvania Canal workers, 43

Ritz, Charles, 42
Rothrock, Joseph Trimble, 118, 119
Seawra Cave, 98
Taylor, John P., 124
Walters, Jacob, 47
Walters, Margaret J., 47
war bond participants, 56
Wentz, Frank H., 125
Yeager, Jacob, 90

Across America, People are Discovering Something Wonderful. Their Heritage.

Arcadia Publishing is the leading local history publisher in the United States. With more than 3,000 titles in print and hundreds of new titles released every year, Arcadia has extensive specialized experience chronicling the history of communities and celebrating America's hidden stories, bringing to life the people, places, and events from the past. To discover the history of other communities across the nation, please visit:

www.arcadiapublishing.com

Customized search tools allow you to find regional history books about the town where you grew up, the cities where your friends and family live, the town where your parents met, or even that retirement spot you've been dreaming about.